CELESTIAL NIGHTS

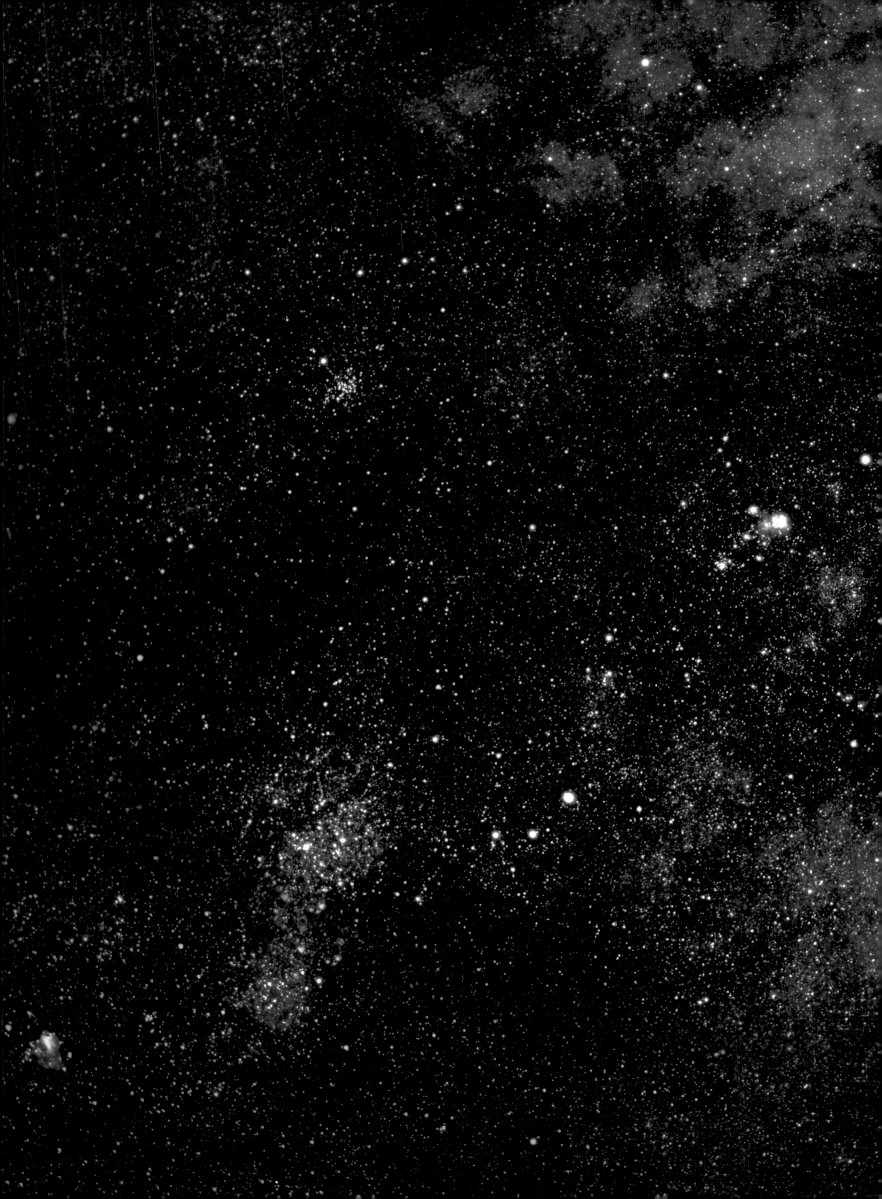

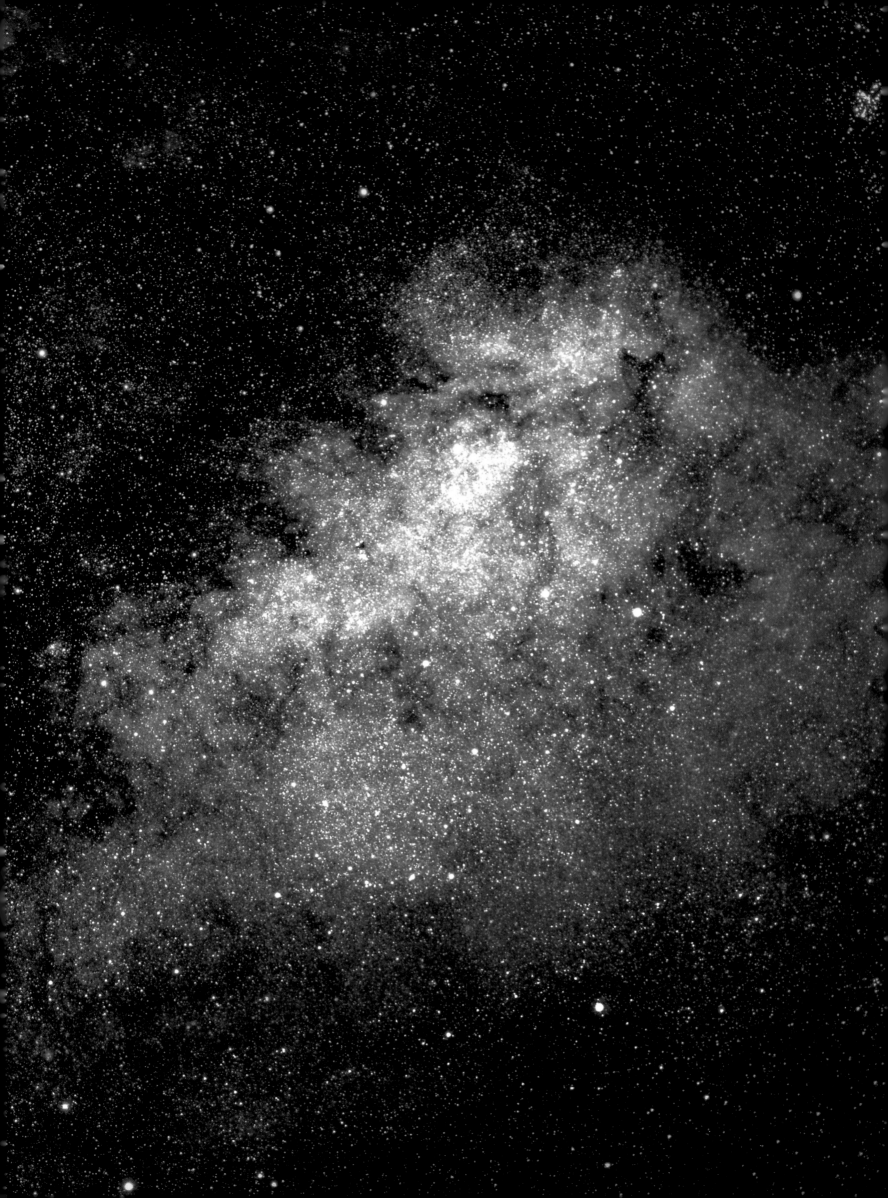

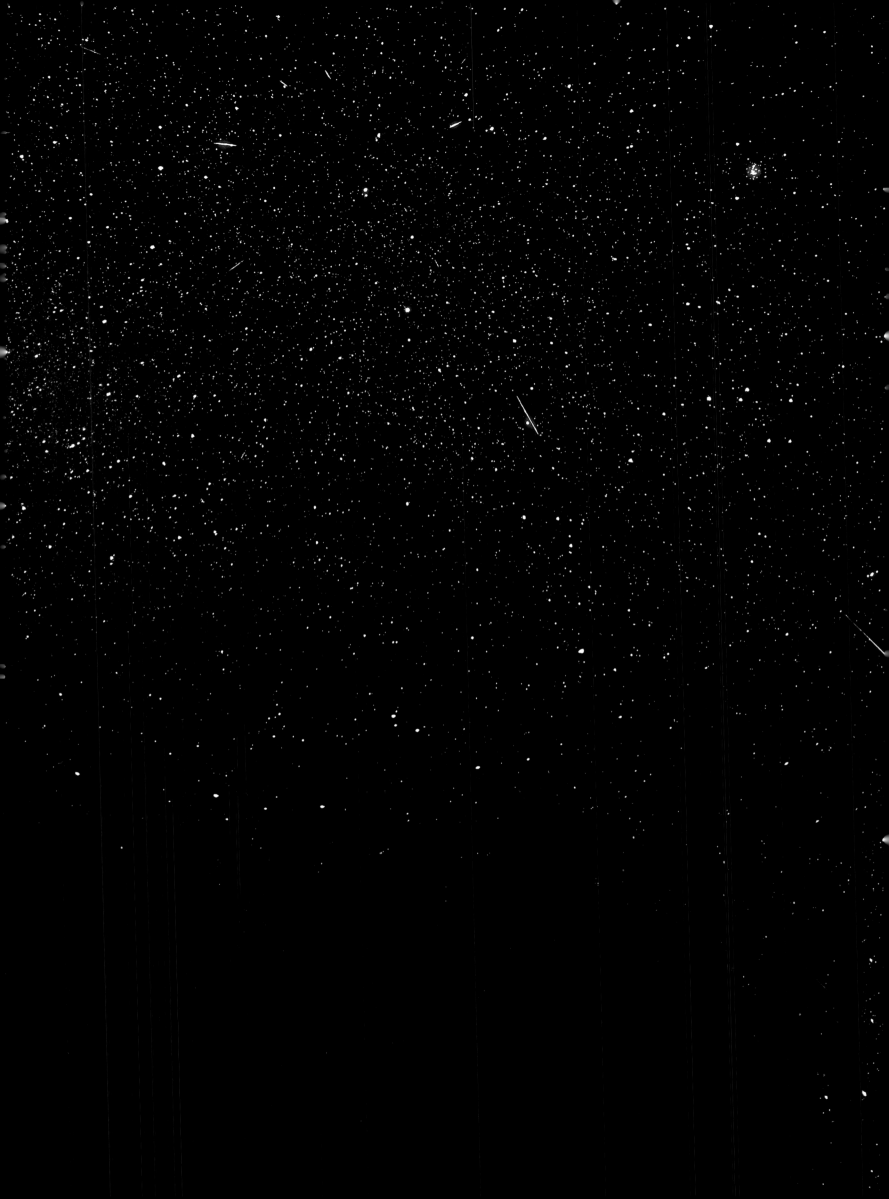

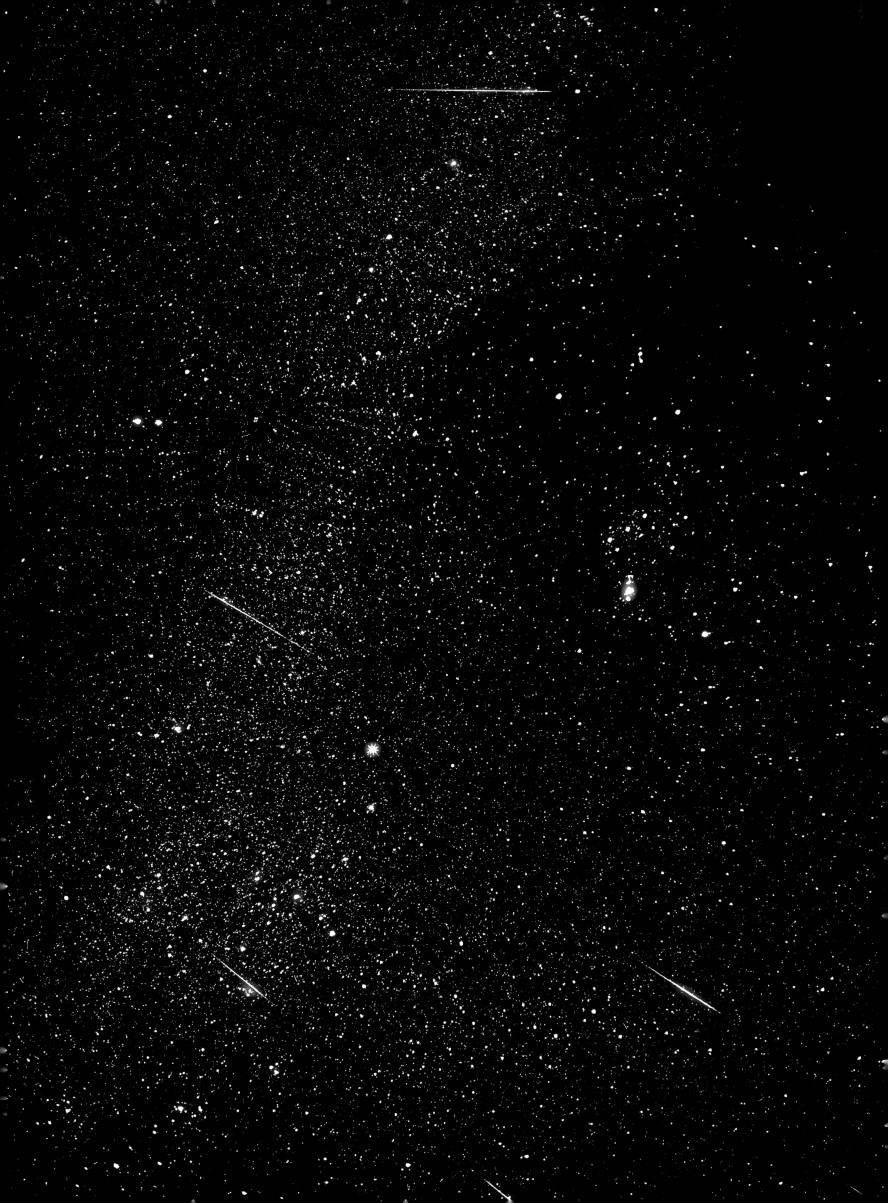

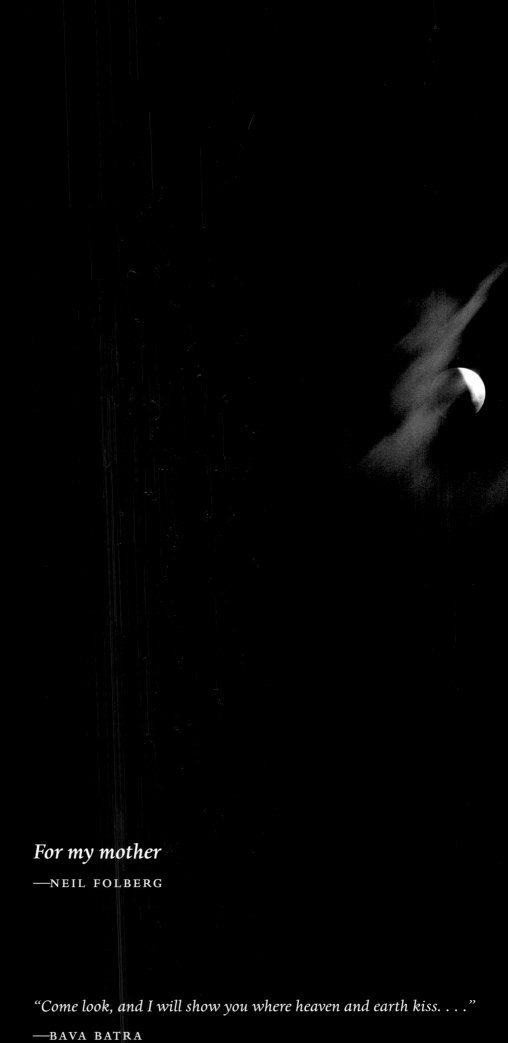

For my mother

—NEIL FOLBERG

"Come look, and I will show you where heaven and earth kiss. . . ."

—BAVA BATRA

CELESTIAL NIGHTS

VISIONS OF AN ANCIENT LAND

PHOTOGRAPHS FROM ISRAEL AND THE SINAI

Photographs by Neil Folberg

Introduction by Timothy Ferris

APERTURE

PAGES 2–3: *GREAT RIFT OF THE MILKY WAY,* 1997
PAGES 4–5: *LEONID METEOR SHOWER,* 1999 OPPOSITE: *LUNAR ECLIPSE,* 1997

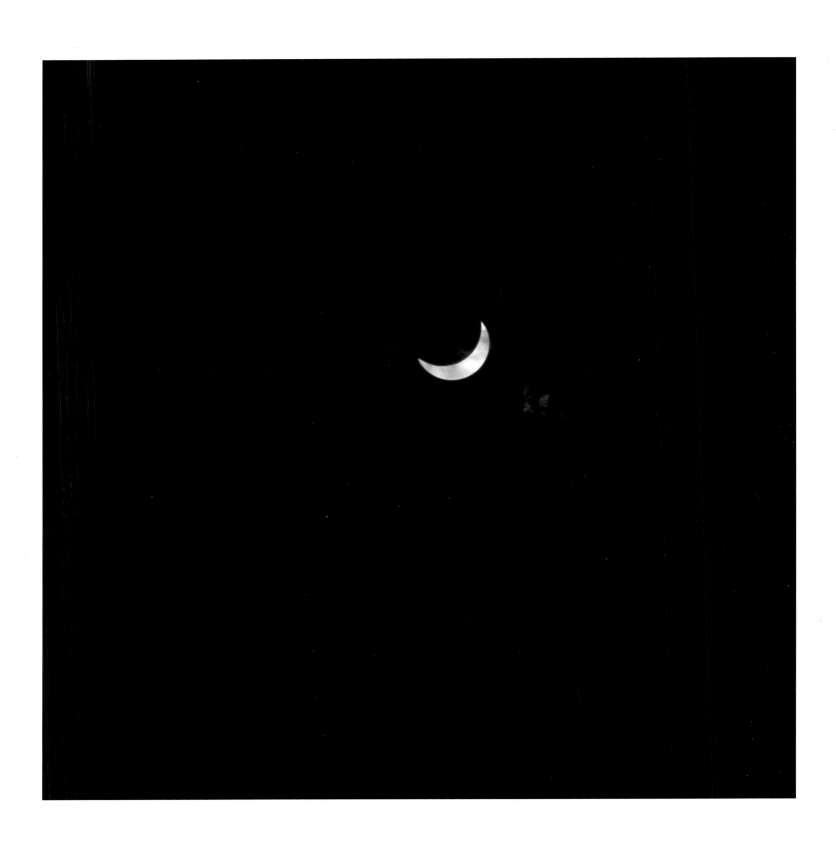

8 *SOLAR ECLIPSE*, 1999

INTRODUCTION

Art and science are so closely akin that they might very well be lumped together. They are certainly necessary to each other, and the delights of either pursuit should satisfy any man.

ROBERT HENRI, *THE ART SPIRIT*

To judge from landscape photographs, you would hardly suspect that the land spends half its time in darkness. Daylight and twilight abound, but with scant exceptions—Ansel Adams's "Moonrise, Hernandez" comes to mind, as do Richard Misrach's night clouds, and some of Akira Fuji's wide-angle constellation studies—few photographs convey the scene in which we find ourselves when we're outside under the stars. (The same might be said of paintings, landscape artists evidently having taken to heart Sir Kenneth Clark's admonition that "night is not a subject for naturalistic painting.")

Which is unfortunate, given the magical qualities of earth and sky by night. The brooding earth seems both to belong to the wider cosmos and, at the same time, to stand a bit apart from it, while the night sky is fathomless—literally so, in that outer space contains more phenomena than human beings will ever know, but also in the sense that it makes a fathomless impression. The unaided eye can see only a few thousand stars, but those who speak of seeing "millions" of them are onto something: For every visible star, many others scintillate just below the threshold of visibility. As bountiful it looks, the night sky is always pregnant with even greater potential.

Astronomers, with the light-gathering power of large telescopes at their disposal, were the first to prove these depths. The word "photography" was coined by an astronomer, John Herschel, and the first photograph of the moon was made by an amateur astronomer, John William Draper, in 1839—the same year that he also took the first photograph of a human face. In the early twentieth century, the optician George Ritchey made superb photographs of galaxies with the slow, fine-grained emulsions available at the time, sometimes exposing a single plate for three full nights at the telescope. In the twenties, Edward Emerson Barnard made high-contrast prints of the Milky Way that helped awaken humanity to the fact that we inhabit a spiral galaxy. In the fifties, William C. Miller produced the first color photo of the Andromeda galaxy, with the forty-eight inch Schmidt camera at Palomar: Reprinted millions of times, it ranks among the icons of modern photography.

Much of this astronomical work, though executed primarily for research purposes, has lasting aesthetic appeal. The deep-space photographs of the astronomers Allan Sandage and Halton Arp look more like art with each passing year, as do the vivid color photos made by David Malin at the Anglo-Australian Observatory in the Southern hemisphere, and of course some of the Hubble Space Telescope images. But precisely because they are taken through large telescopes, which have narrow fields of view, scientific photographs of the stars have omitted the earthly component of the night-sky experience. Even E. E. Bernard, who used a wide-angle "astrograph" equipped with a high-resolution portrait lens, avoided including any foreground "obstructions" in his starfield photos. The astronomers were out to capture the sky, not the nighttime landscape.

Meanwhile, a number of photographers have tried their hand at night work. I've done it myself. In my youth I made star-trail photographs, illuminating palm trees in the foreground by shooting off strobe lights while the shutter was open. Some of these photos were published, but none would be mistaken for art. Part of the problem is that the camera, unlike the eye, has trouble handling the dynamic range and differing appearance of a dark landscape below and blazing stars above. If the night landscape is illuminated—by moonlight, say, or city lights—the stars tend to be reduced to a flat backdrop. If, on the other hand, the

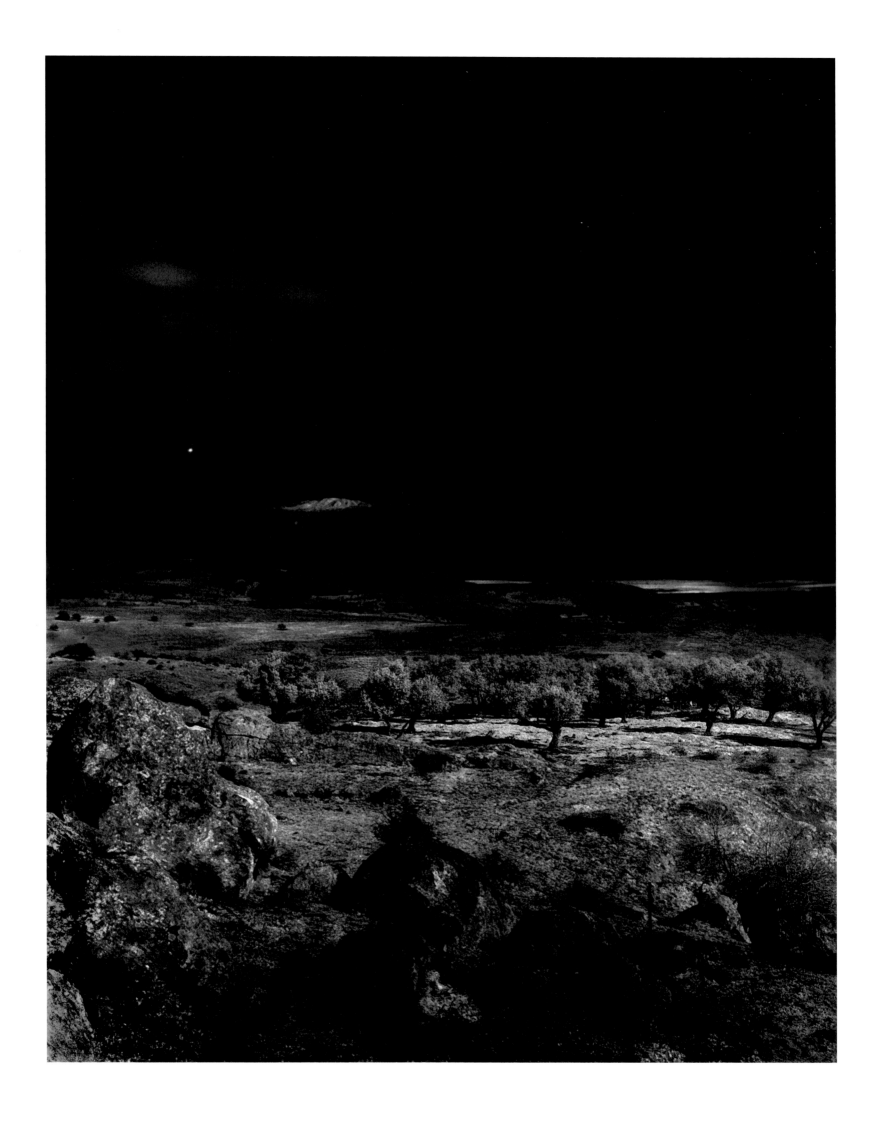

landscape is left dark, it turns into a cardboard cutout, as obtrusive as an Easter bonnet worn by a lady sitting in front of you in a movie theater. Some photographers have tried to get around this difficulty by shooting the sky and the land separately and then combining them in the darkroom or on a computer, but such shotgun weddings have seldom worked out. Some are visually striking, others technically impressive, but few look real.

Technical issues aside, I suspect that there is a deeper problem, having to do with the dialogue between nature at large and that subset of it which is incorporated into the human mind and eye. We started out—it is safe to say, without descending into Rousseauistic fantasies of noble savages—closer to nature: Our ancestors prayed to the gods of rain and wind, communed with the animals, and projected their fables onto the stars. With the rise of science and technology came estrangement: Rain, wind, and even animals were interpreted in machine-like terms, the stars turned out to be far away, and poets lamented our newfound isolation and loneliness. Now, it seems, we are getting closer to nature again, but from a new platform, one built on the premise of estrangement. We seek out the wind and rain, dressed in comfortable rain gear and knowing that we can always retreat to an even more comfortable tent. We "love" animals and seek to preserve them and their habitats, now that we are no longer obliged to sleep with the pigs when it gets frosty outside. And we are getting back in touch with the stars: Hundreds of thousands of people have bought or built telescopes with which to investigate the heavens, and there is a burgeoning organization, the International Dark-Sky Association, devoted to attenuating the "light pollution" that deprives millions of children in cities and suburbs of the sight of the Milky Way. But the basis of our aesthetic relationship with the stars remains unclear, now that they are no longer a web of fairy tales, but not yet a gigantic real-estate development. Scientists and science writers have made tentative efforts to define it, but forging a new aesthetic is ultimately the work of artists, and few artists to date have taken this project on. There is as yet no real tradition of photographing the sky and the earth at night—akin, say, to the language developed by painters like Albert Bierstadt and Frederic Edwin Church to render the towering peaks of the American West.

But now, suddenly, we have a real start, in Neil Folberg's night-sky photographs. These images actually do evoke, with striking force and authenticity, the experience of being out at night under the stars. They elicit the three primary aspects of that experience: the stars themselves, the Earth, and the human mind, which perceives earth and sky, and was responsible for cutting our planet out of the cosmos in the first place, leaving the hole that the arts and the sciences have been trying to fill ever since. In these images the night sky looks the way we really see it, or would like to. The earth retains its almost spooky air of both belonging to the cosmos and yet standing apart from it somehow, and the mind, included for once with earth and stars as part of an integrated whole, feels at home at last.

Looking at these photographs is as easy as taking a breather on a scenic hike, but their seeming effortlessness was, as is usually the case, attained through hard work and guile. Folberg employs infrared and high-speed films for his landscapes and hypersensitized technical pan films for the sky. He often combines two exposures, as many have done, but he gets away with it as few have managed to do. What he is after—and, in my view, achieves—is not just what nature looks like at night, but how it feels.

"The relationship of these photographs to reality is, I confess, tenuous at best," Neil wrote, when I asked him a few questions about his work. "Every one of these photographs is either something I saw and photographed, something I thought I saw but couldn't photograph due to the technical limitations of photography, or something I wished to have seen but didn't. If I saw it and photographed it, it was because a photo could be made with the photographic materials available—or because I was able to make it in two exposures, reconstruct it using digital imaging techniques, and then print it on standard photographic materials. I spend a lot of time looking at night skies and the landscape they illuminate, but because the materials are inadequate to the task I have to use combinations of photography and digital imaging to 'reconstruct' the image I saw. And sometimes it is pure imagination—but imagination based in the very concrete reality of this ancient and hallowed land and our view of the heavens. The photographs that include landscape are all this landscape, without question. And the skies are real skies."

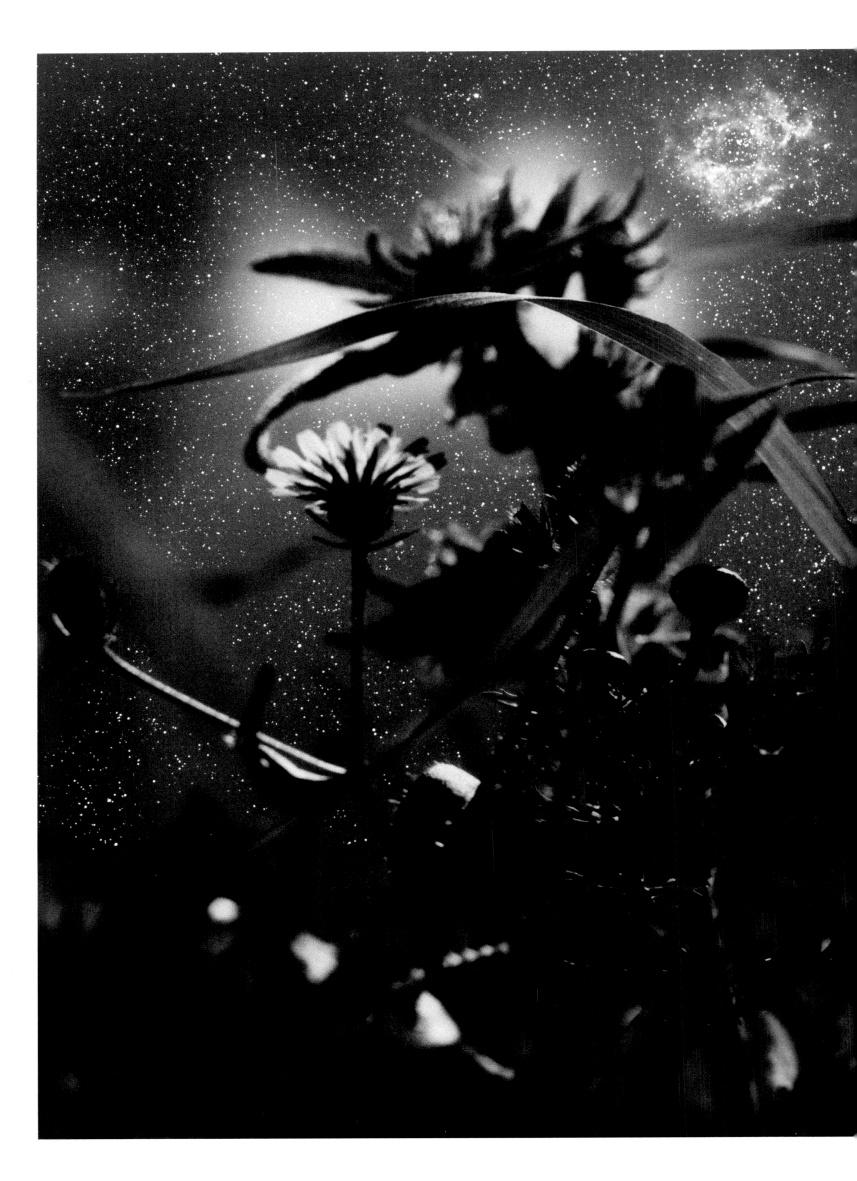

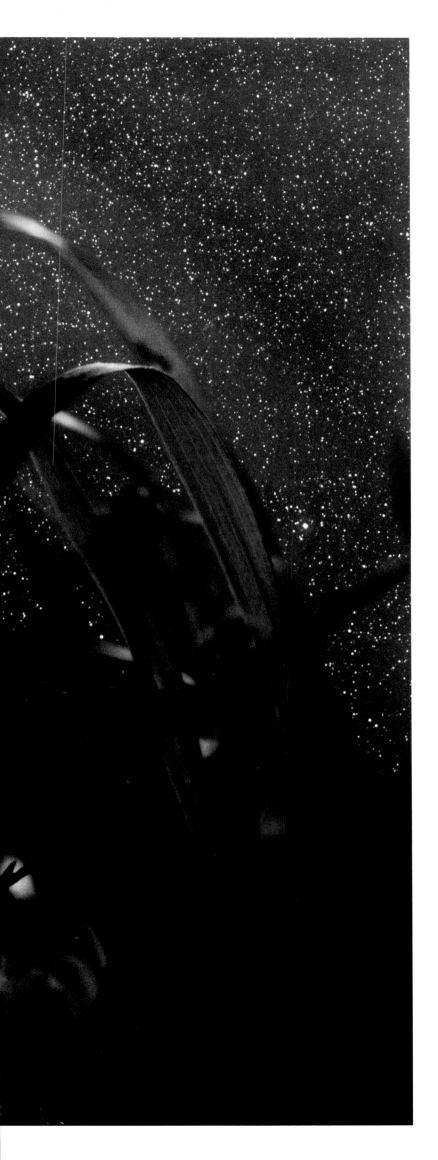

In the artifice of its creation and the naturalness of its results, Neil's art calls into question what happens when we see—how properly to understand the relationship between the human mind and the wider universe from which the mind has arisen. The eye is part of the brain—the one exposed part, covered by a gleaming, aqueous, semi-permeable membrane resembling the meningeal layer that sheathes the rest of the brain—and, as such, the eye embodies the dialogue between the mind and the rest of the cosmos. Yet the question of how it works, of how we see, remains mysterious.

Euclid thought of sight as an active projection of a ray from the eye out into the world, lighting objects as if by a flashlight beam. With the rise of science generally, and the publication of Isaac Newton's *Optics* in particular, the eye came to be regarded as a passive organ into which light falls. With the advent of photography, the eye, unsurprisingly, was described as a camera—with a lens, an iris diaphragm, and a retina that plays the role of film. When television came along, the optic nerve was compared to a TV camera's data cable, carrying the image "to the brain." But these metaphors didn't hold up, either. Philosophers objected that to portray the eye as a camera was to start down the path of infinite regress: If the eye simply projects a picture into the brain, they asked, who looks at the picture? Scientists, for their part, found that the

optic nerve lacks sufficient bandwidth to transmit the entire picture captured by the eye to the rest of the brain. Hence the eye cannot just act passively, like a camera, but must actively process and reduce data before sending it along, presumably using algorithms that communicate with the complex visual centers located deep inside the brain.

Quantum physics and relativity, meanwhile, appear to have moved the fulcrum of vision to a point in space somewhere between the eye and the perceived object. Special relativity teaches that time stands still for objects moving at the velocity of light. Since photons move at light speed—they are light—one is led to the odd consideration that if you could interview a photon that struck your eye after journeying to Earth from the star Altair, seventeen light years away, it would tell you that it made the trip in zero time. Quantum physics teaches that certain quantities of that photon remained undecided until the moment that you saw it—whereupon those aspects were decided for the entire history of the photon, ever since it left Altair! (Of course, that doesn't sound so strange if indeed, as the photon would testify, it left Altair and landed on your eye at the same moment.) Such riddles are unlikely to be cleared up until a unified theory is composed that fully incorporates both quantum physics and relativity, if then. But it does seem plausible that the universe will come to be seen as less cold and distant, and more participatory and involving, than has been the case in the past—and that vision will prove to be neither a wholly passive nor wholly active phenomenon, but something like a long-distance handshake between the perceiver and the perceived.

And that is how these photographs look to me, with their mingled sense of the distance and the intimacy of stars and stones by night. They evince the vitality of art and science alike, as a pair of sturdy legs to carry us outside, where we can take in the wider scheme of things.

—TIMOTHY FERRIS
Rocky Hill Observatory, 2001

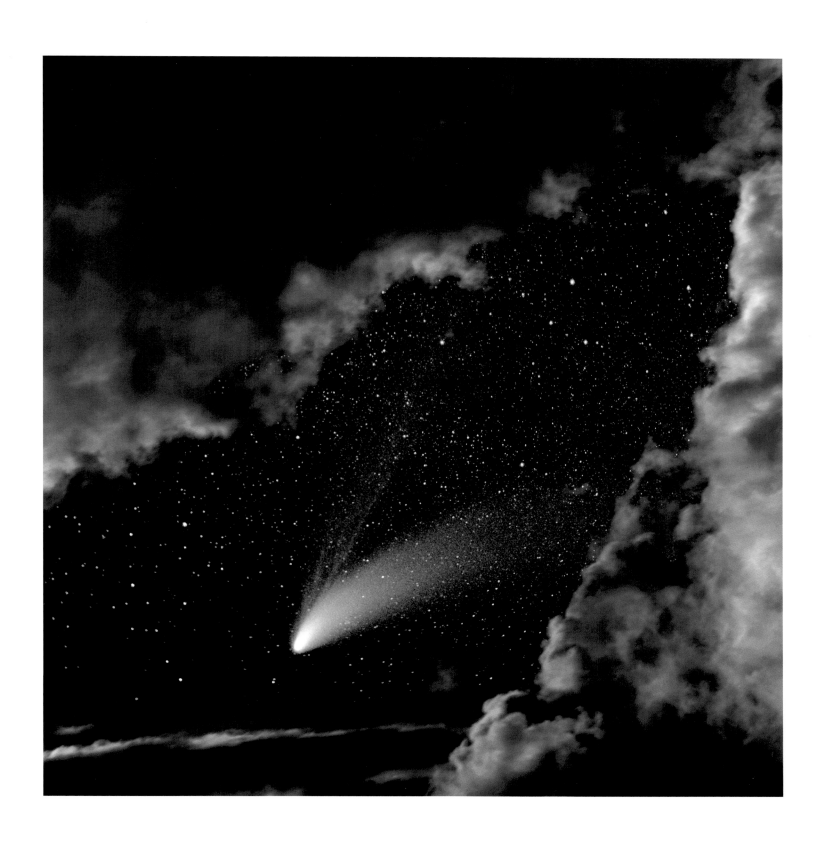

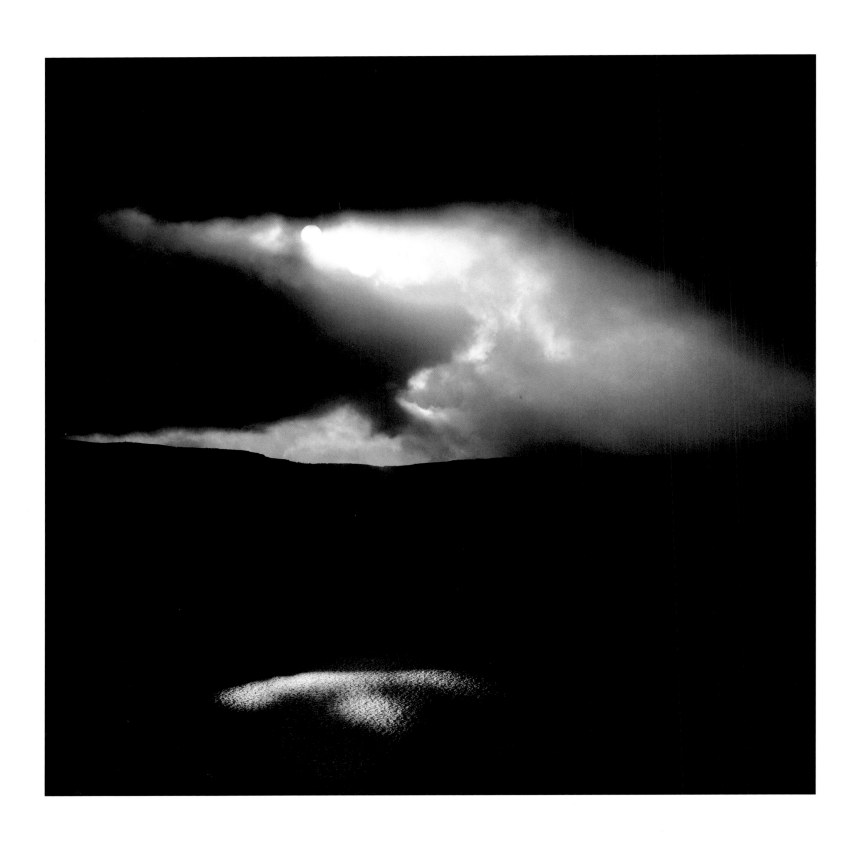

18 *AS A DOVE*, 1999

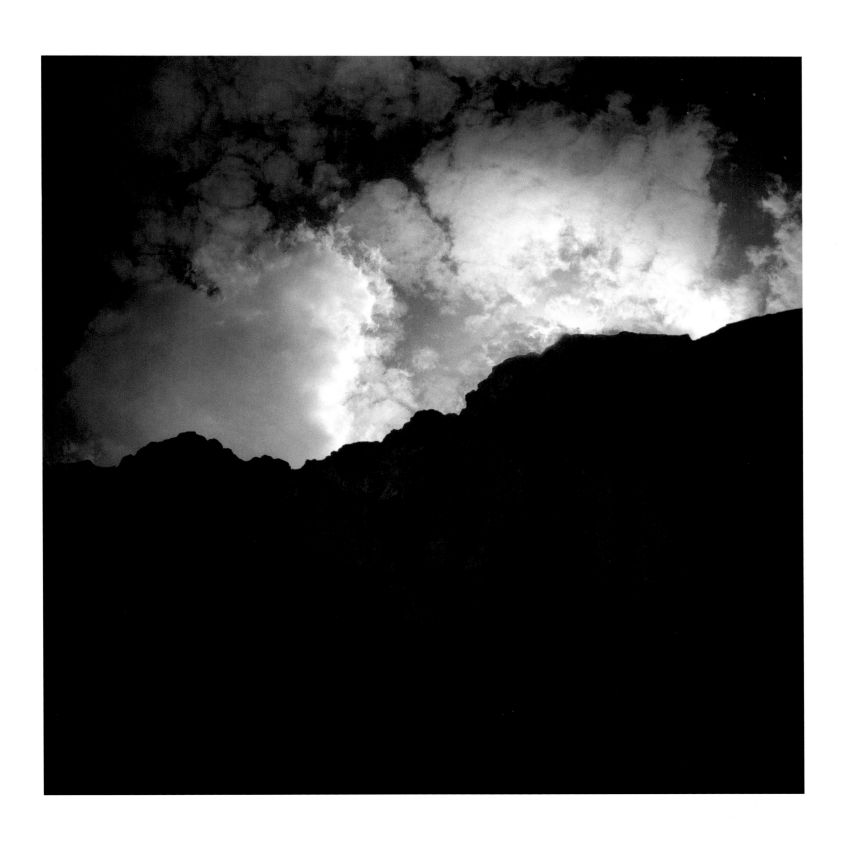

AMUDEI AMRAM, 2000 19

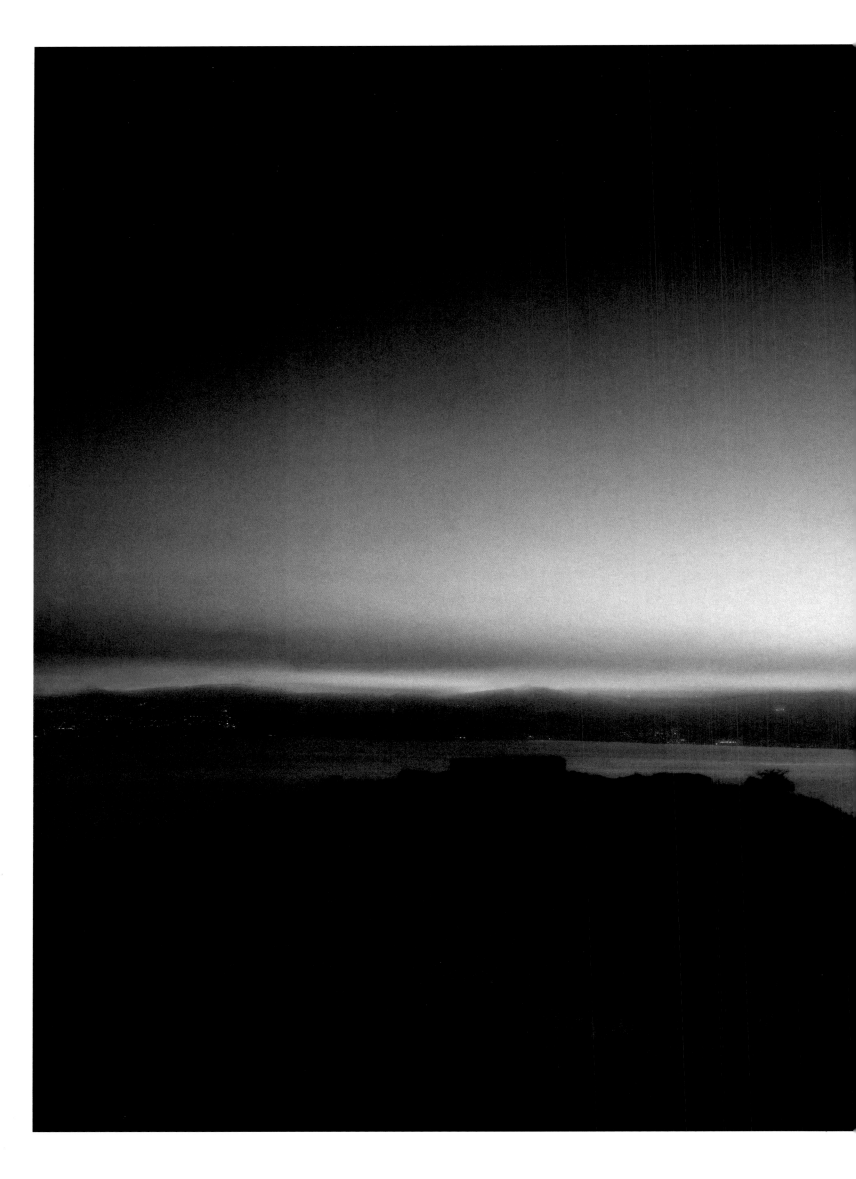

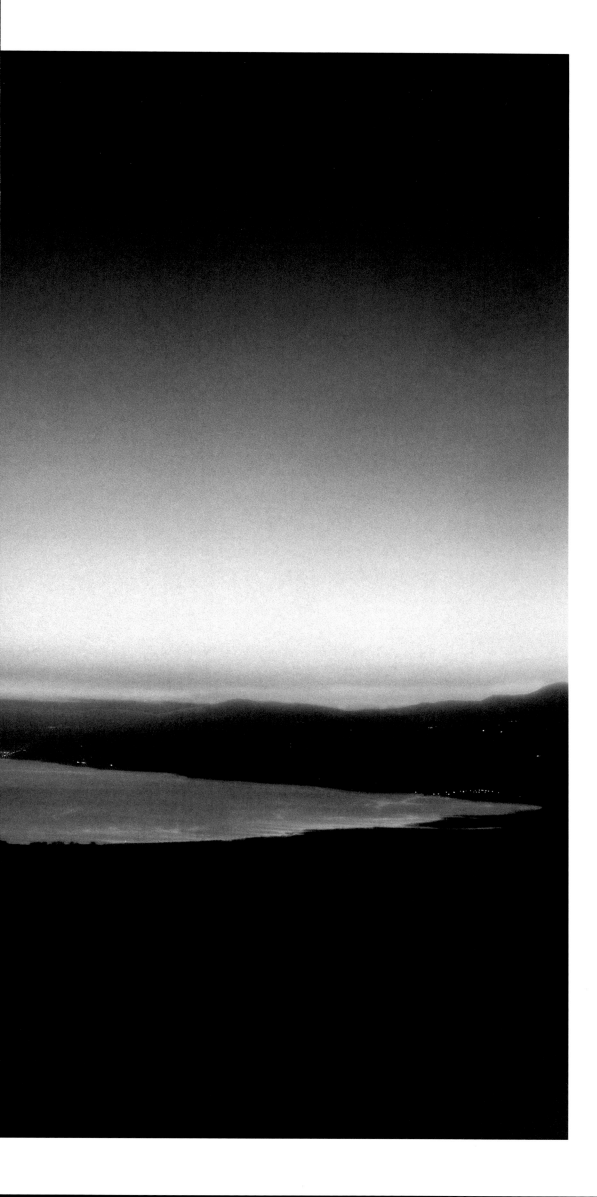

KANAF & KINERET, 2000

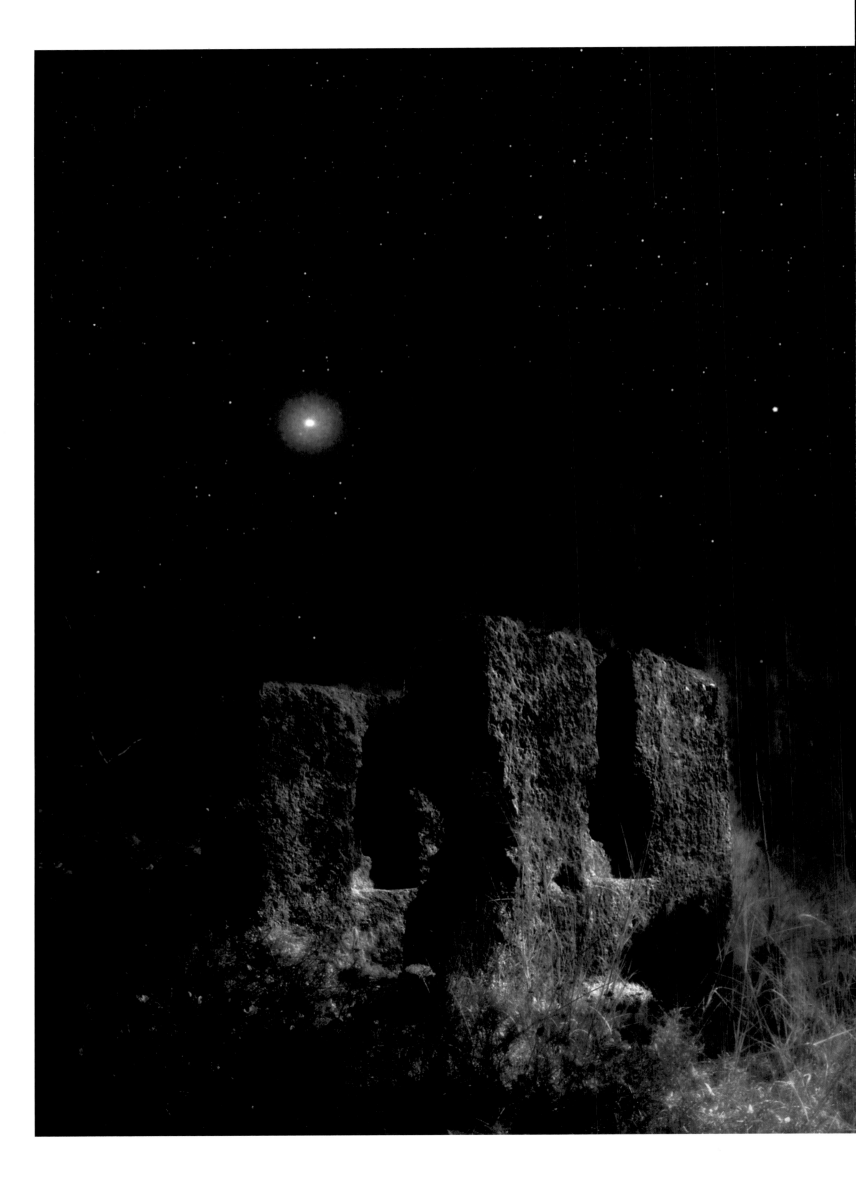

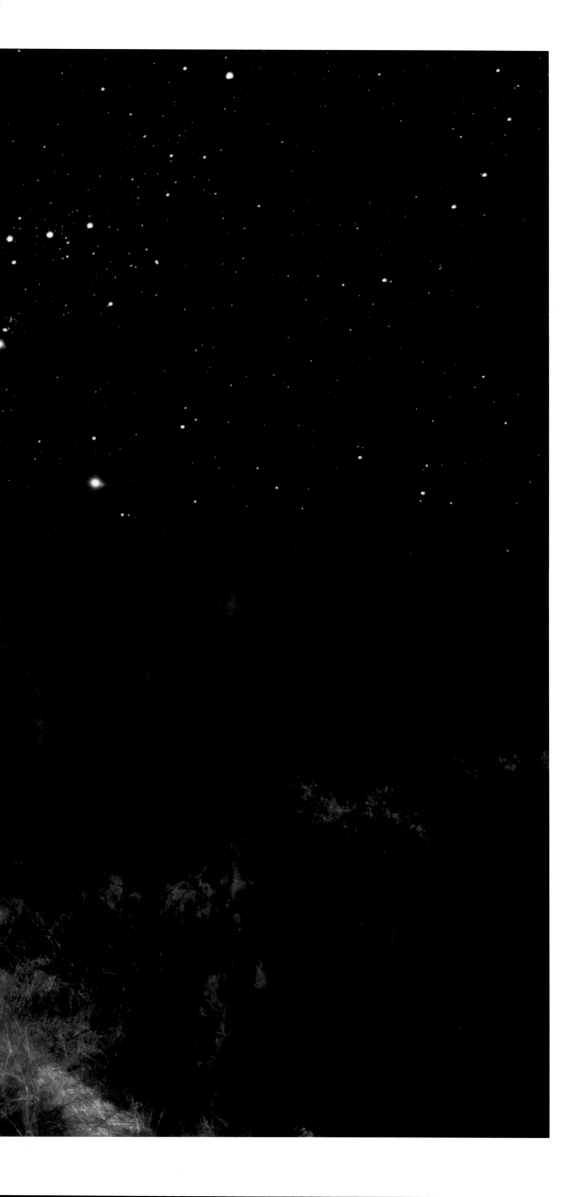

NAHAL NATIV, 1997

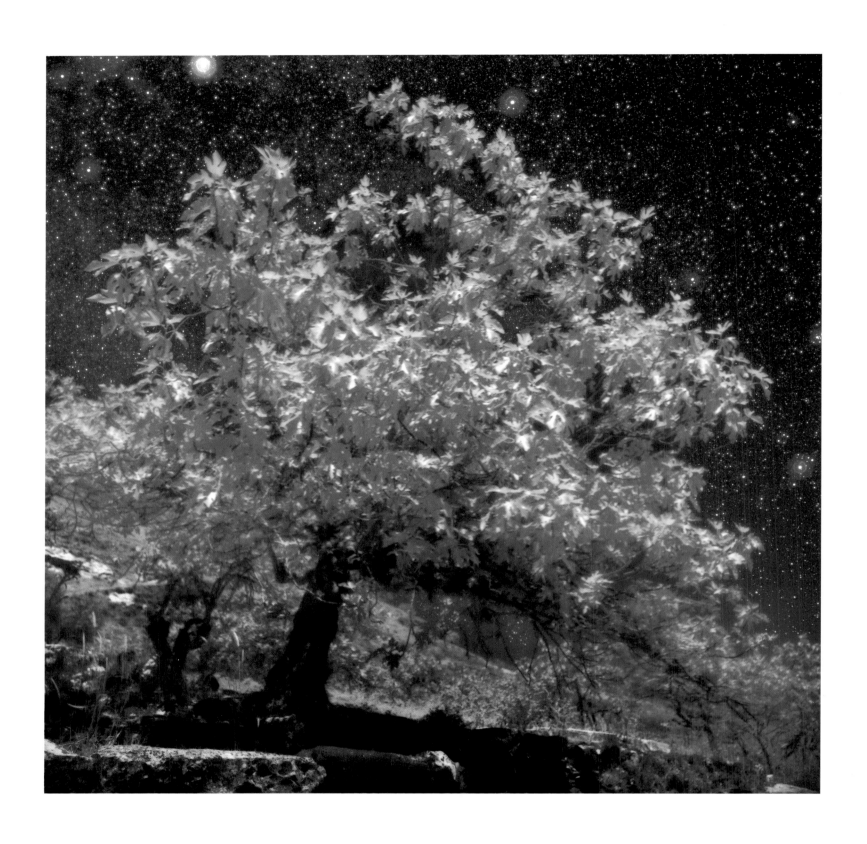

24 *FIG TREE*, 2000

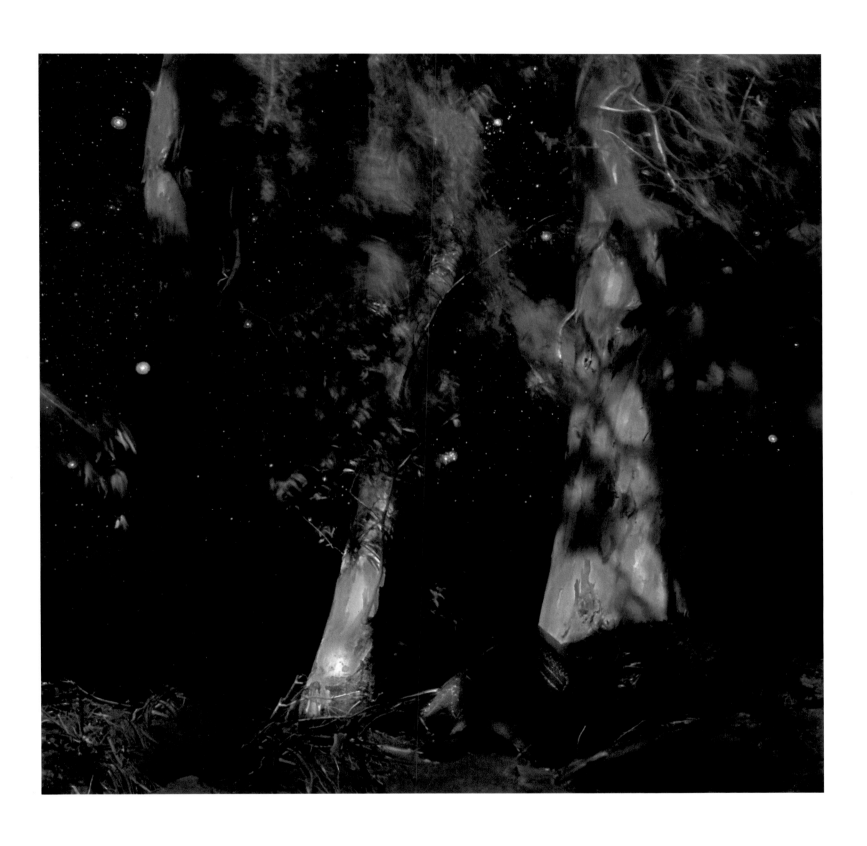

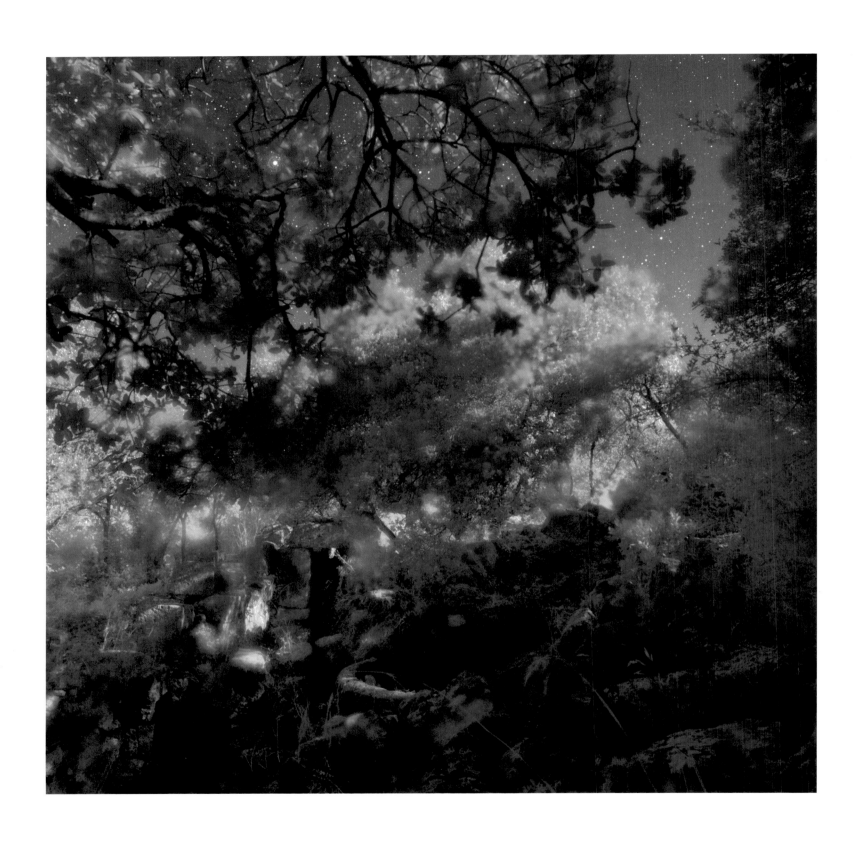

26 *DANELA*, 2000

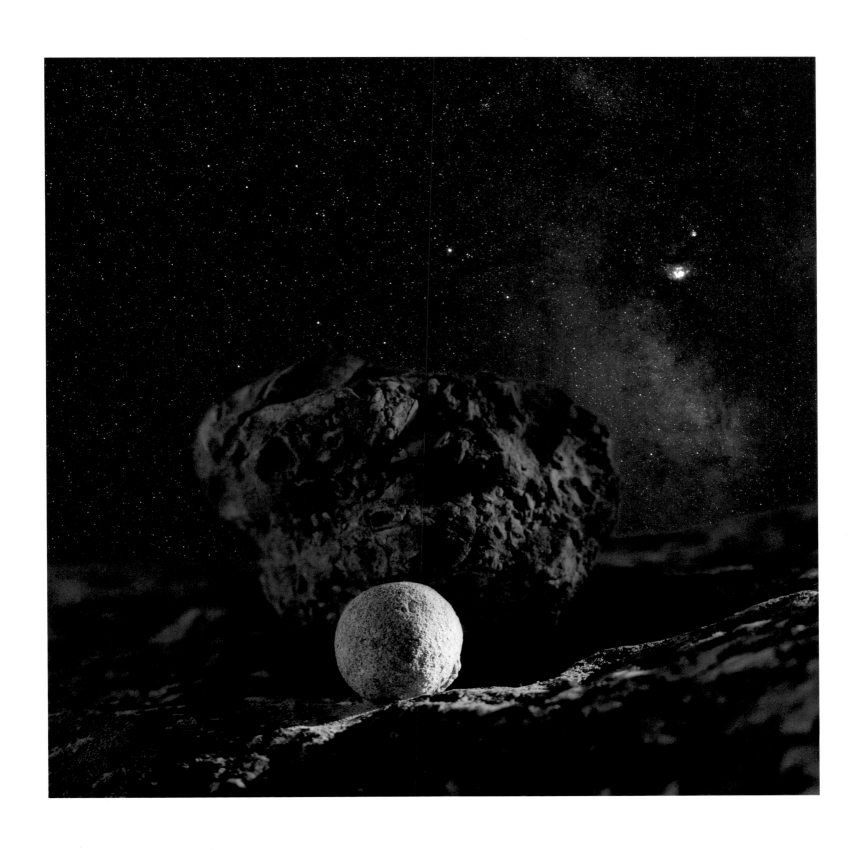

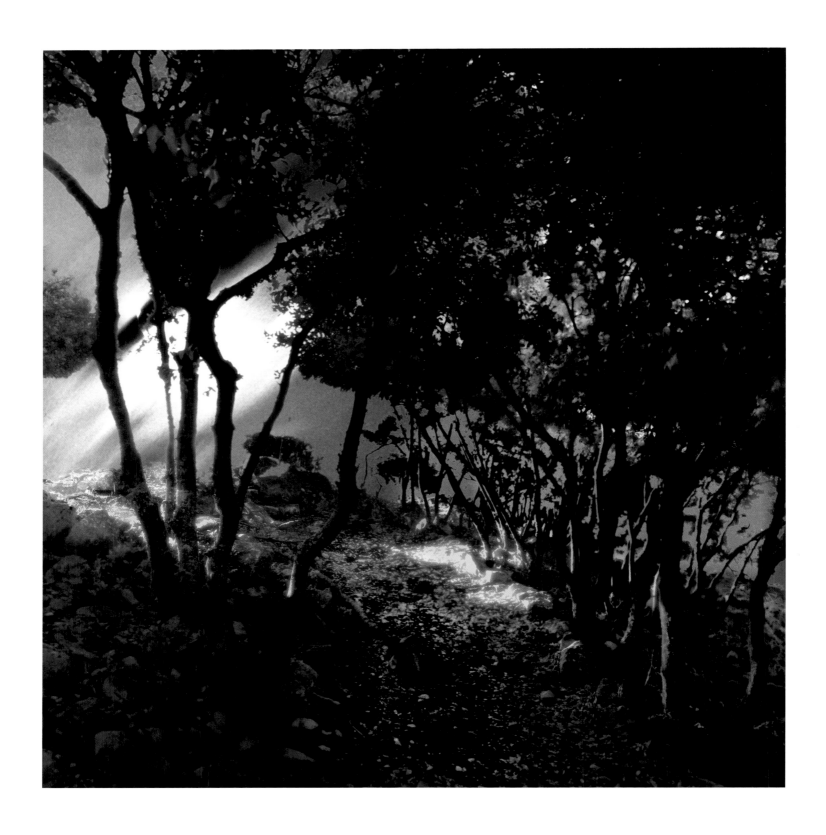

28 *FOREST*, 1999

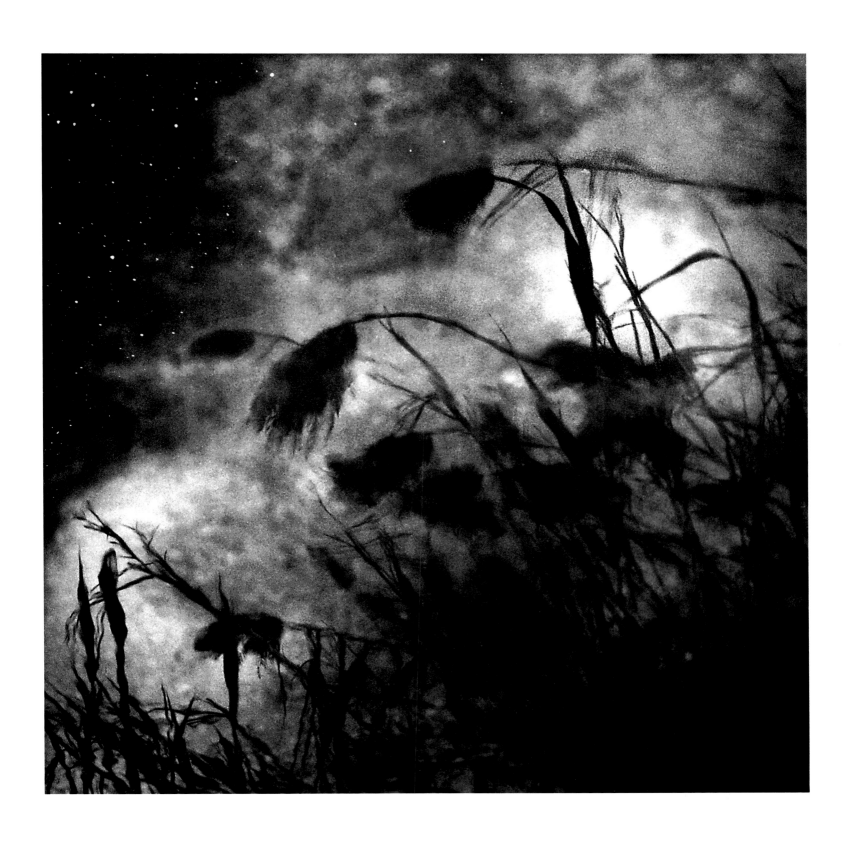

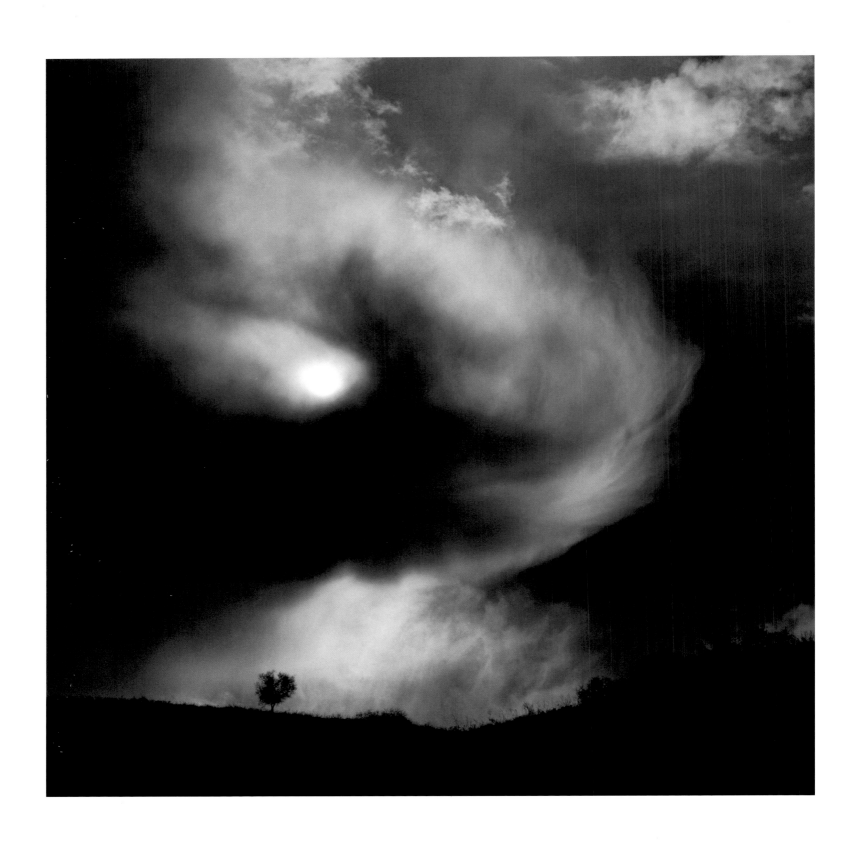

30 *NAHAL DISHON,* 2001

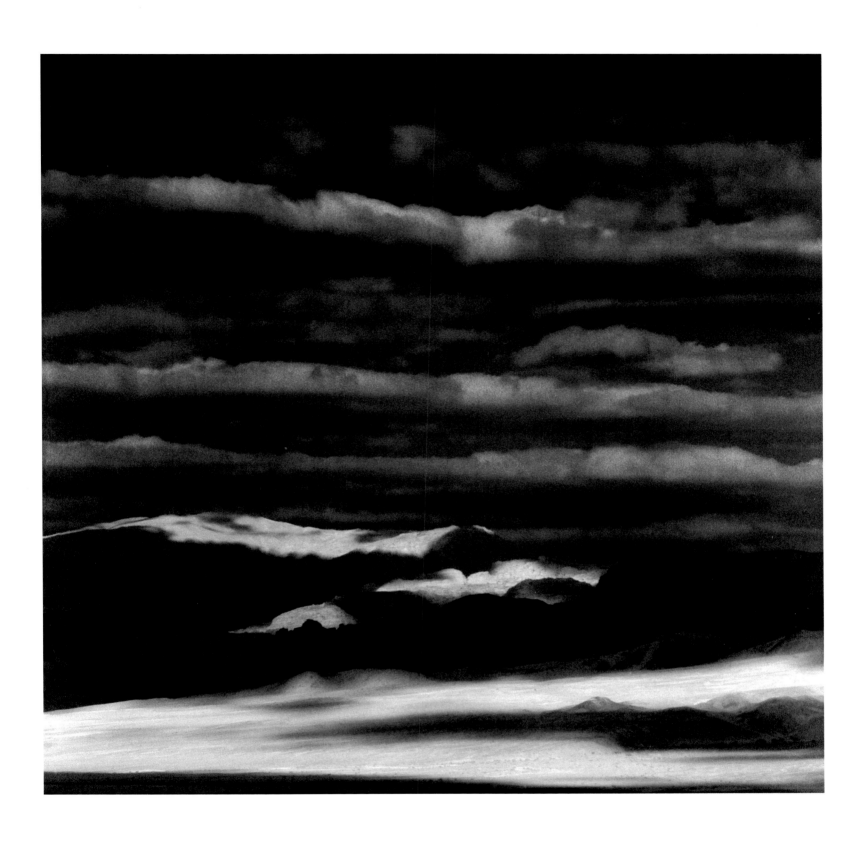

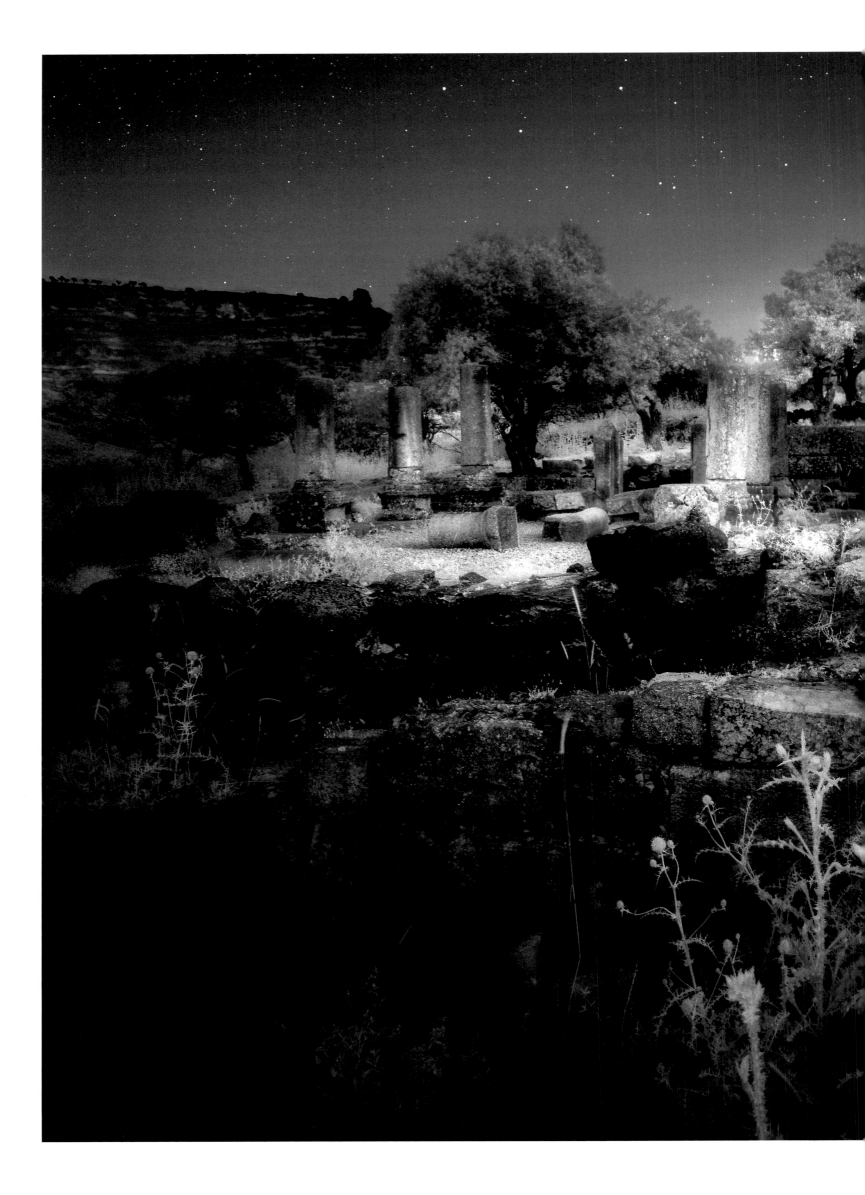

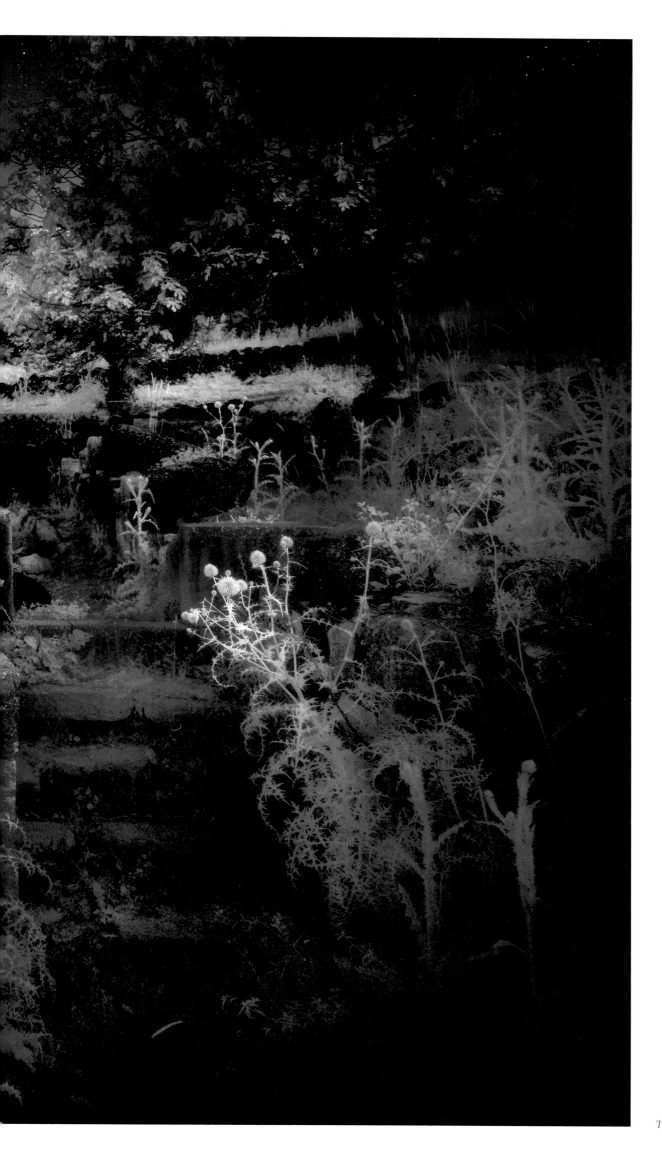

THISTLES, GUSH HALAV, 2000

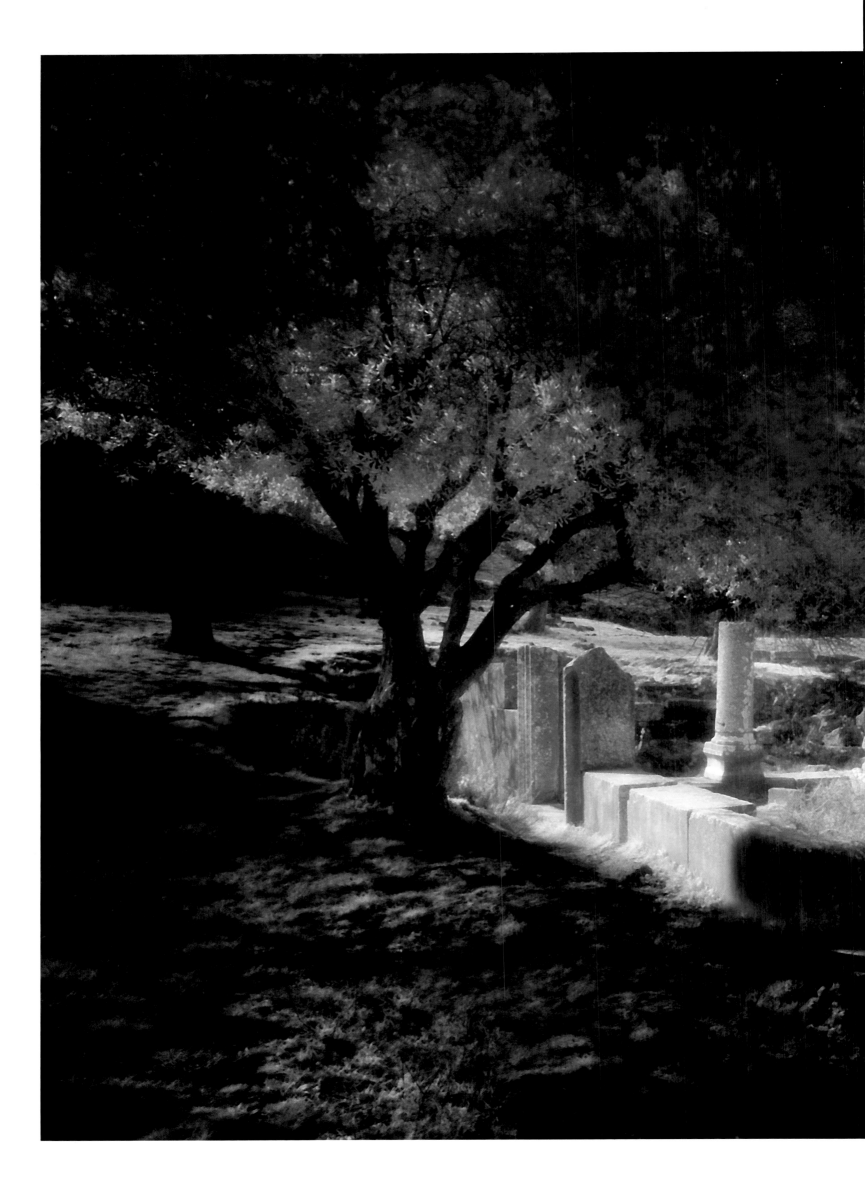

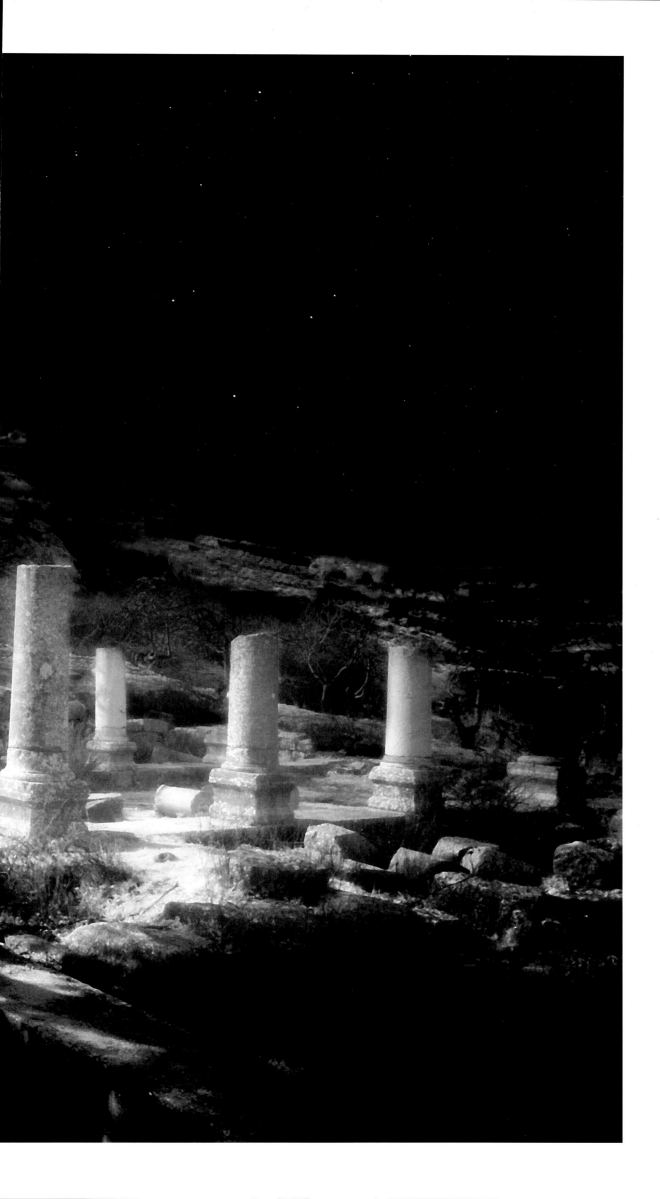

ANCIENT SYNAGOGUE,
GUSH HALAV, 1997

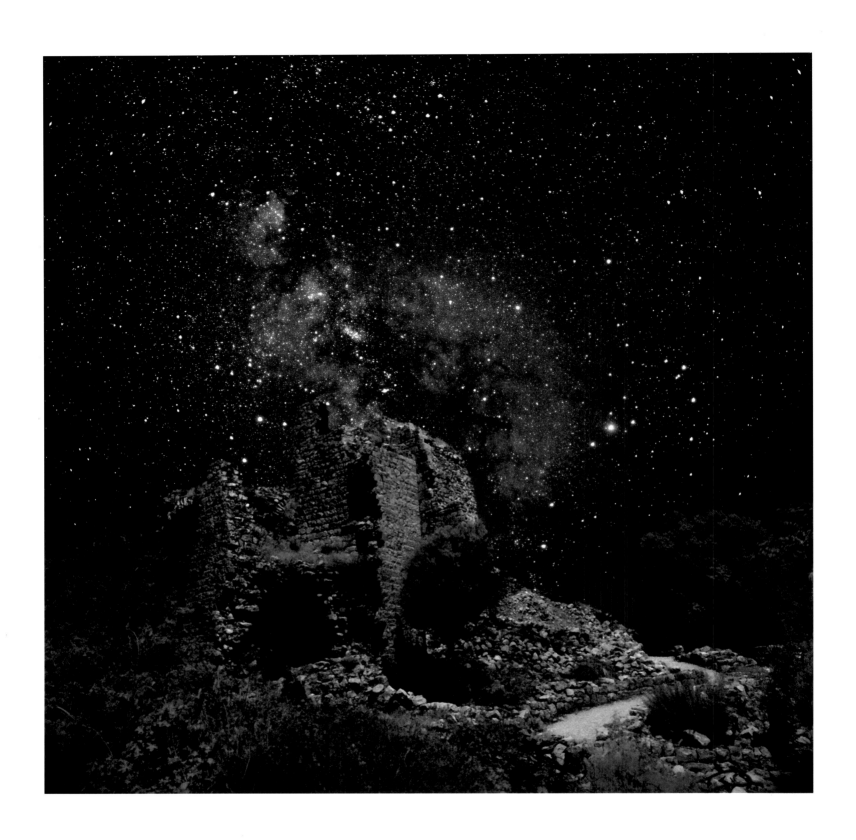

36 *SCORPIUS MILKY WAY RISING*, 1997

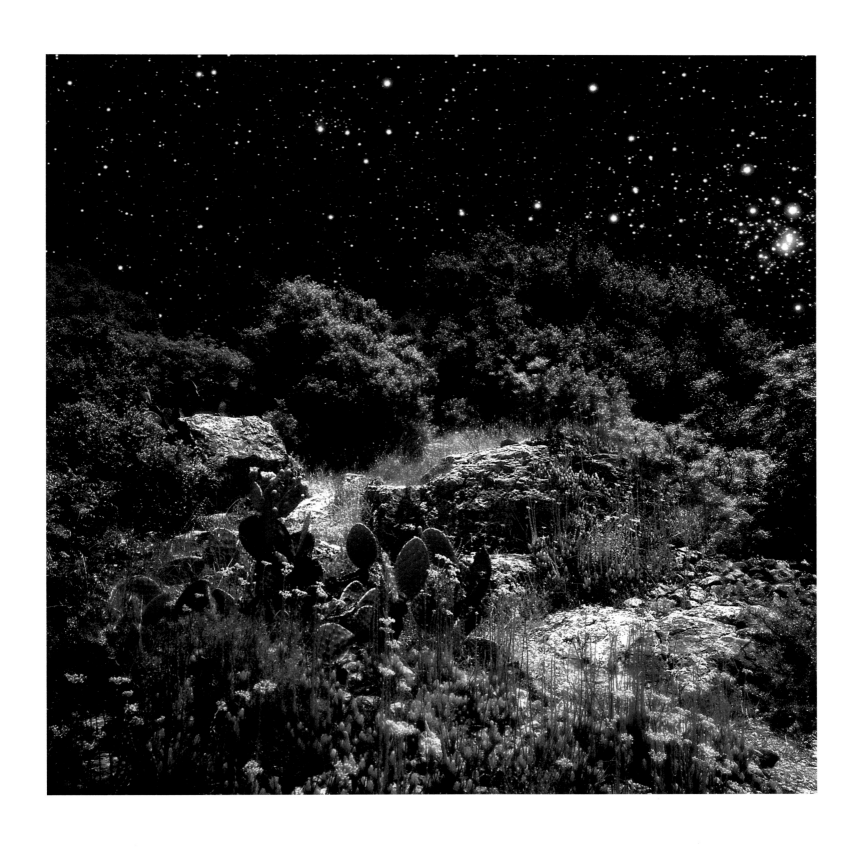

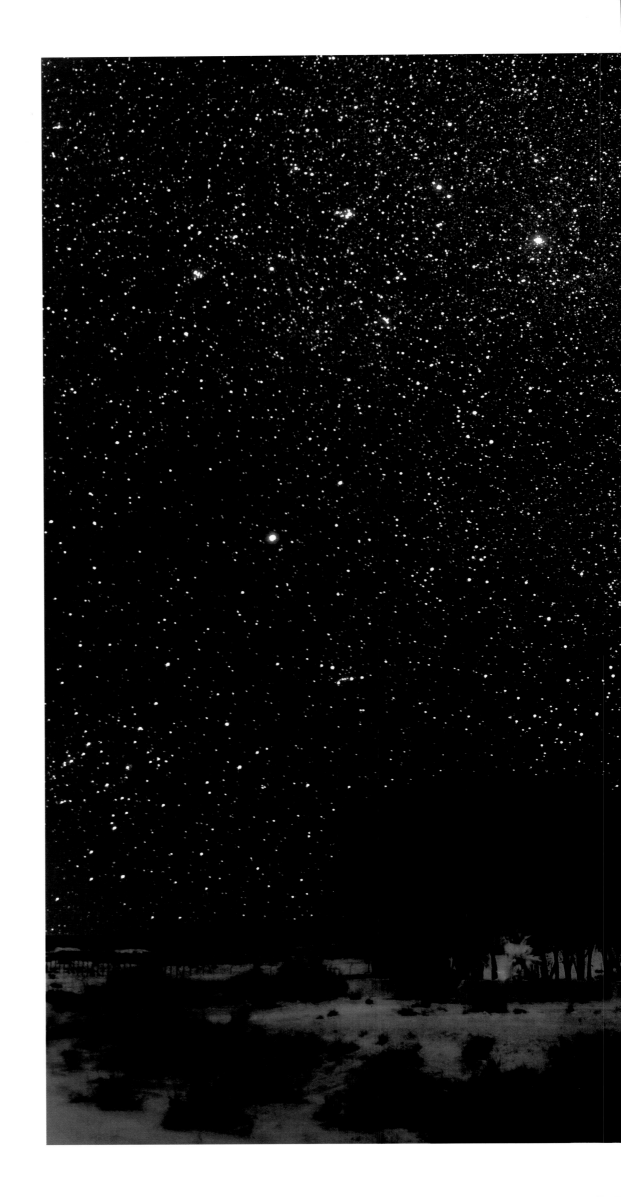

STARRY GROVE, 1999

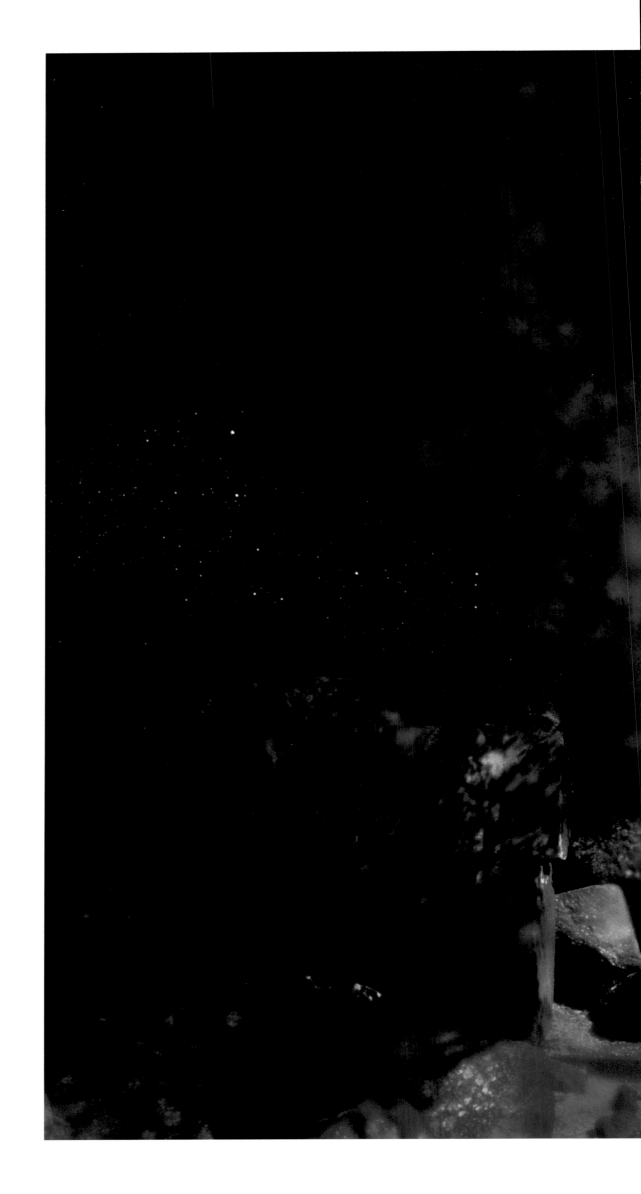

ANCIENT SYNAGOGUE,
GOLAN 1999

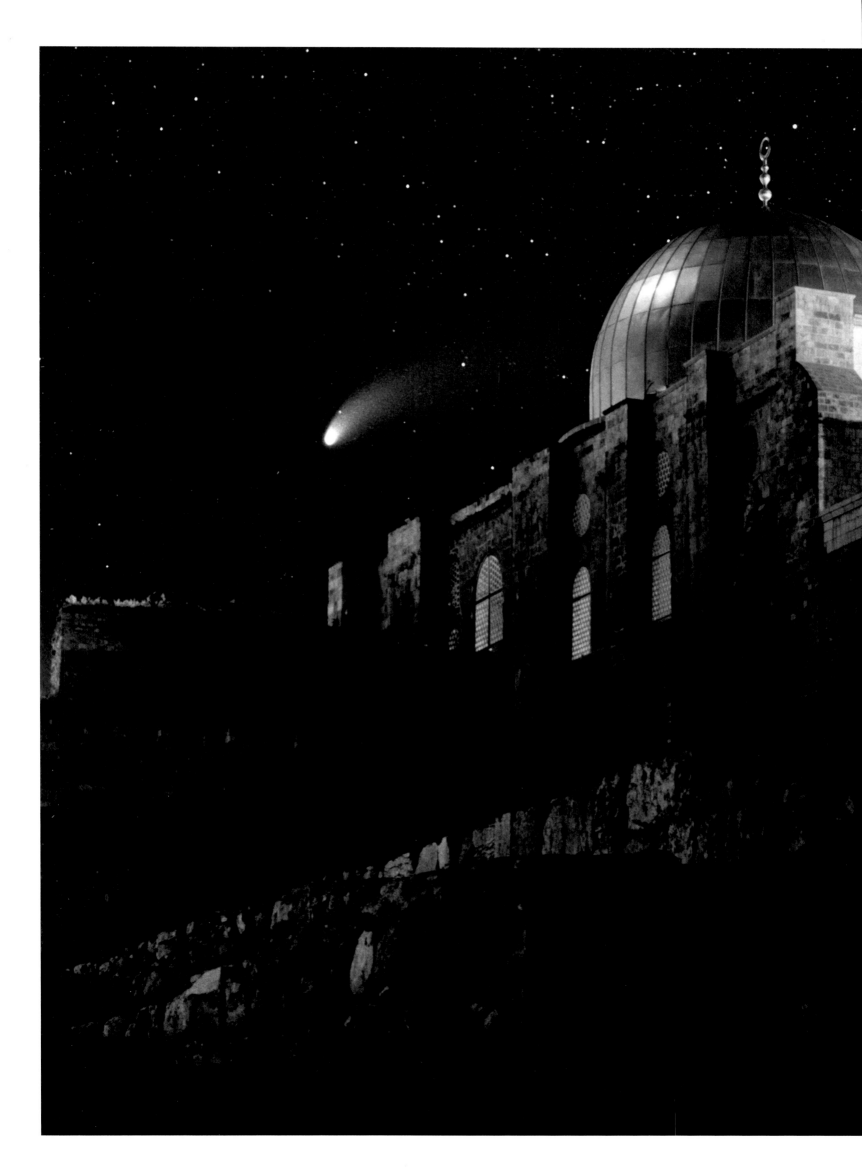

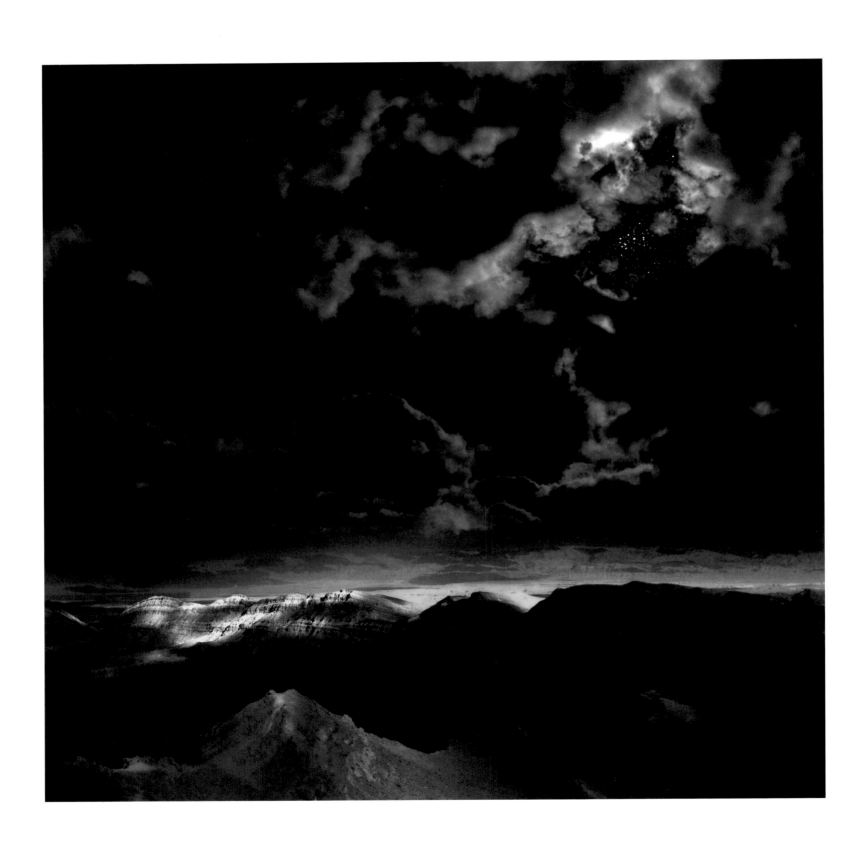

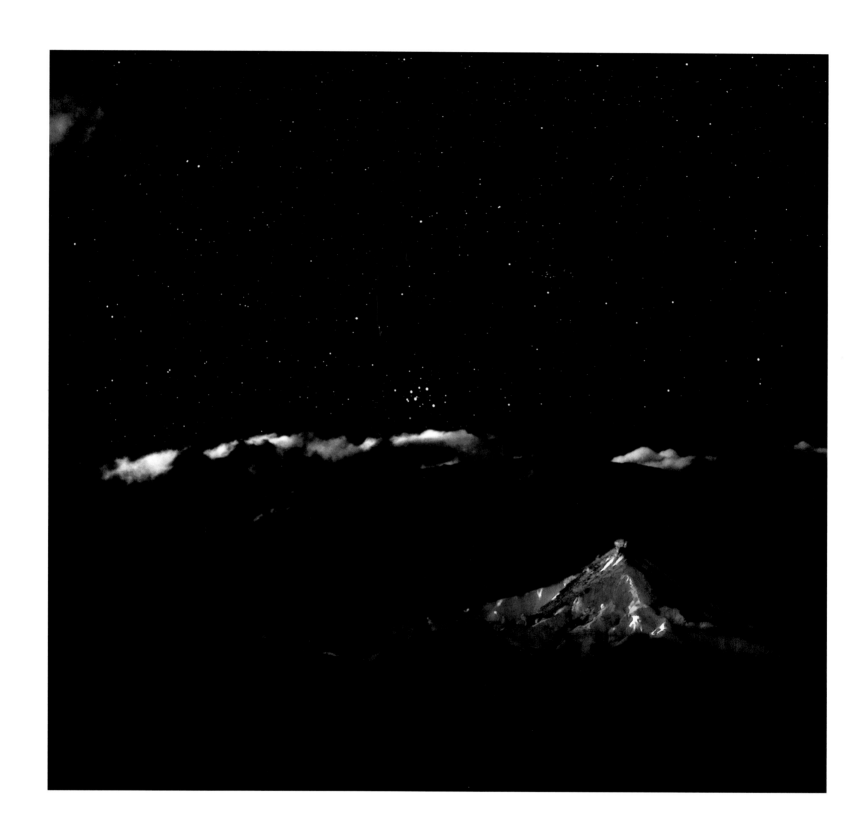

44 *HAR PITAM*, 1999

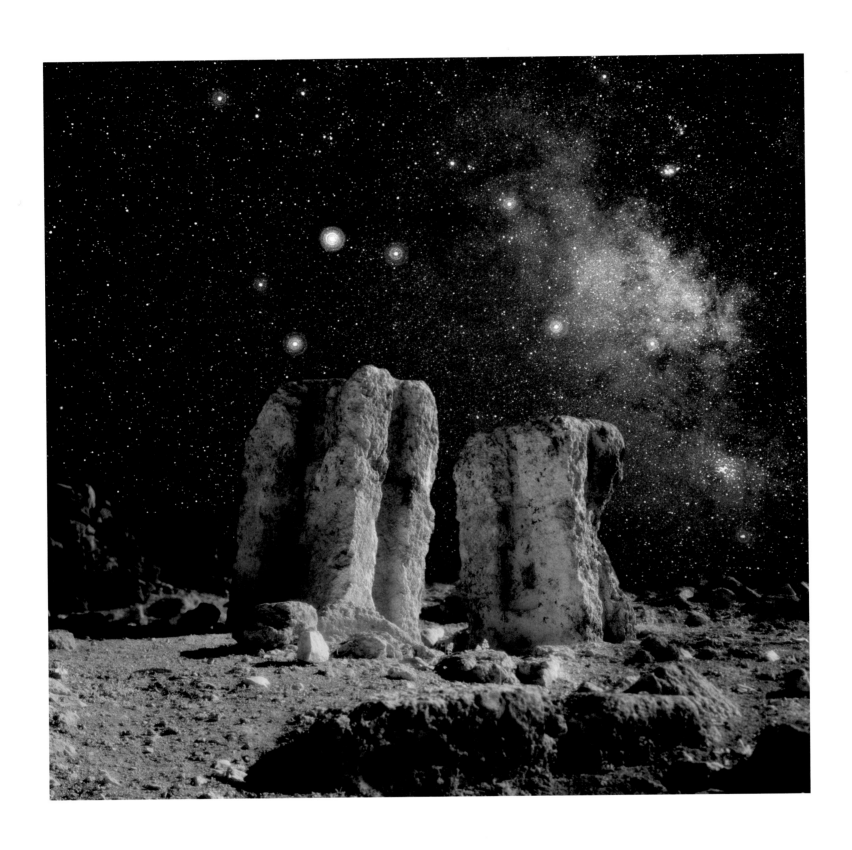

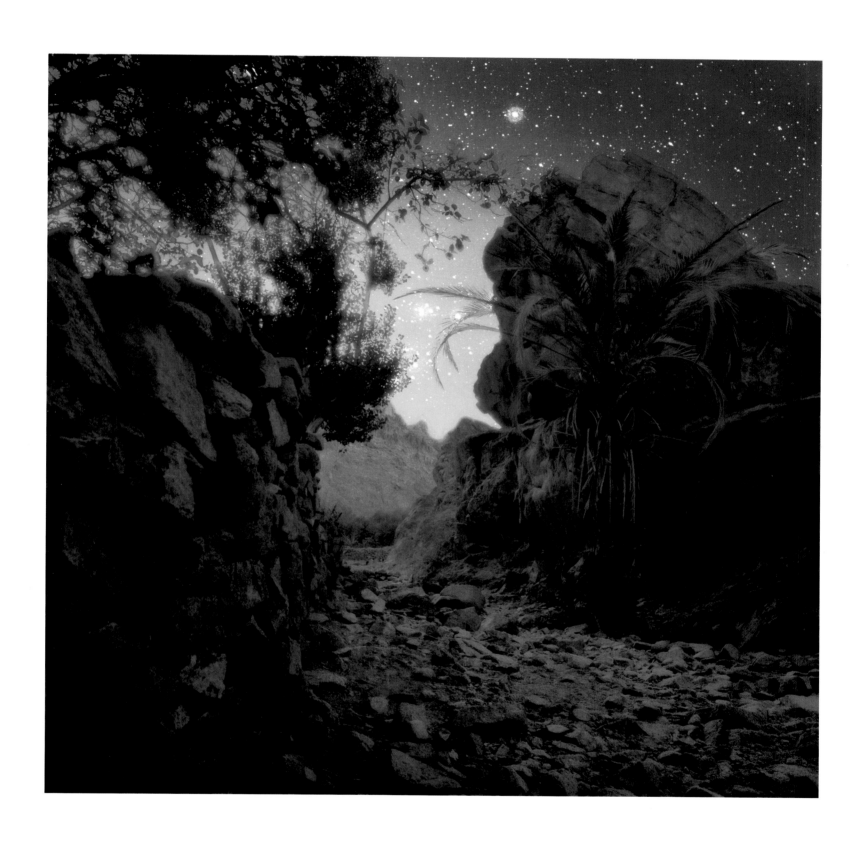

42 *FIRST LIGHT, WADI ZAWATIN, SINAI, 2000*

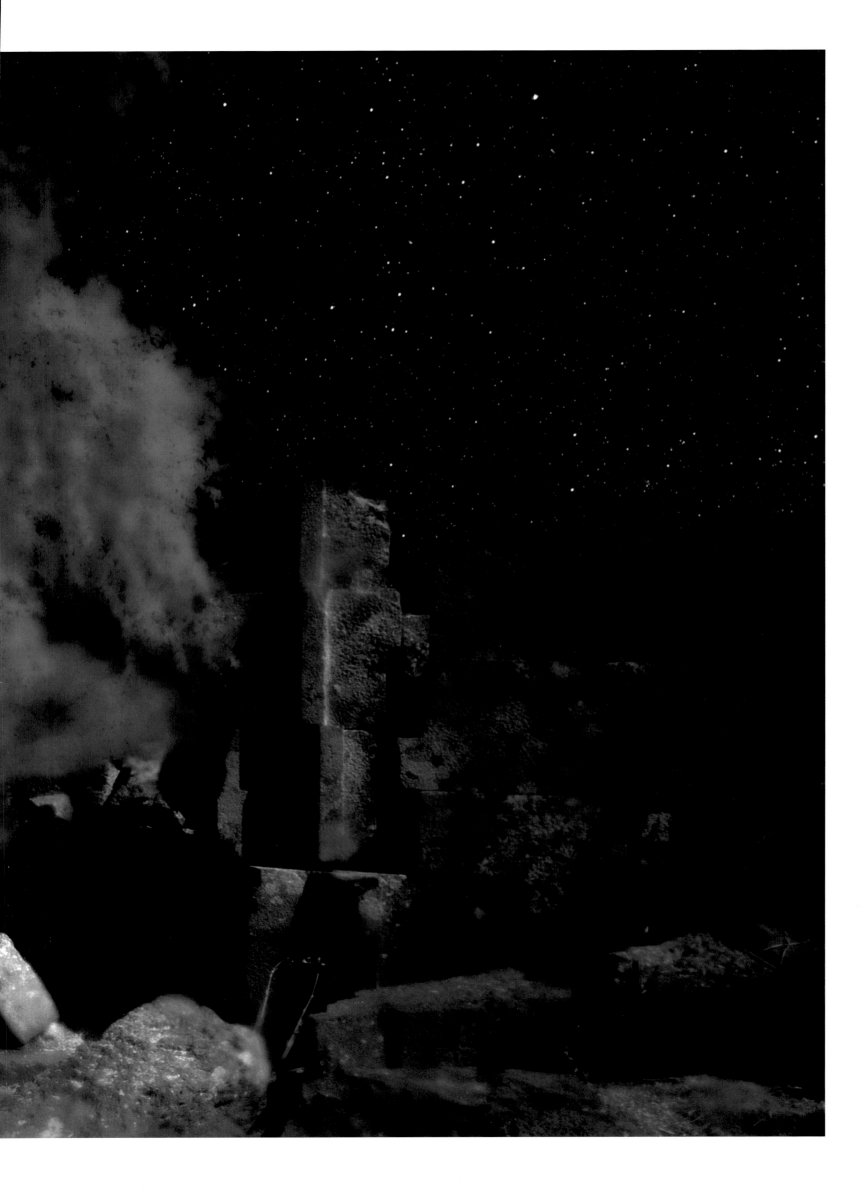

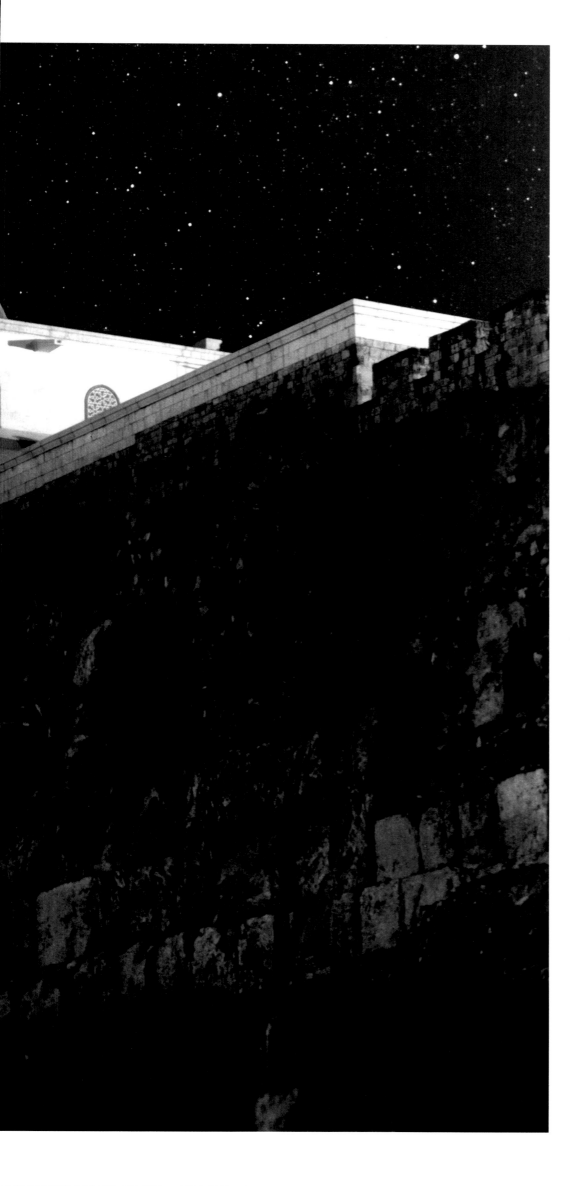

TEMPLE MOUNT, JERUSALEM 1998

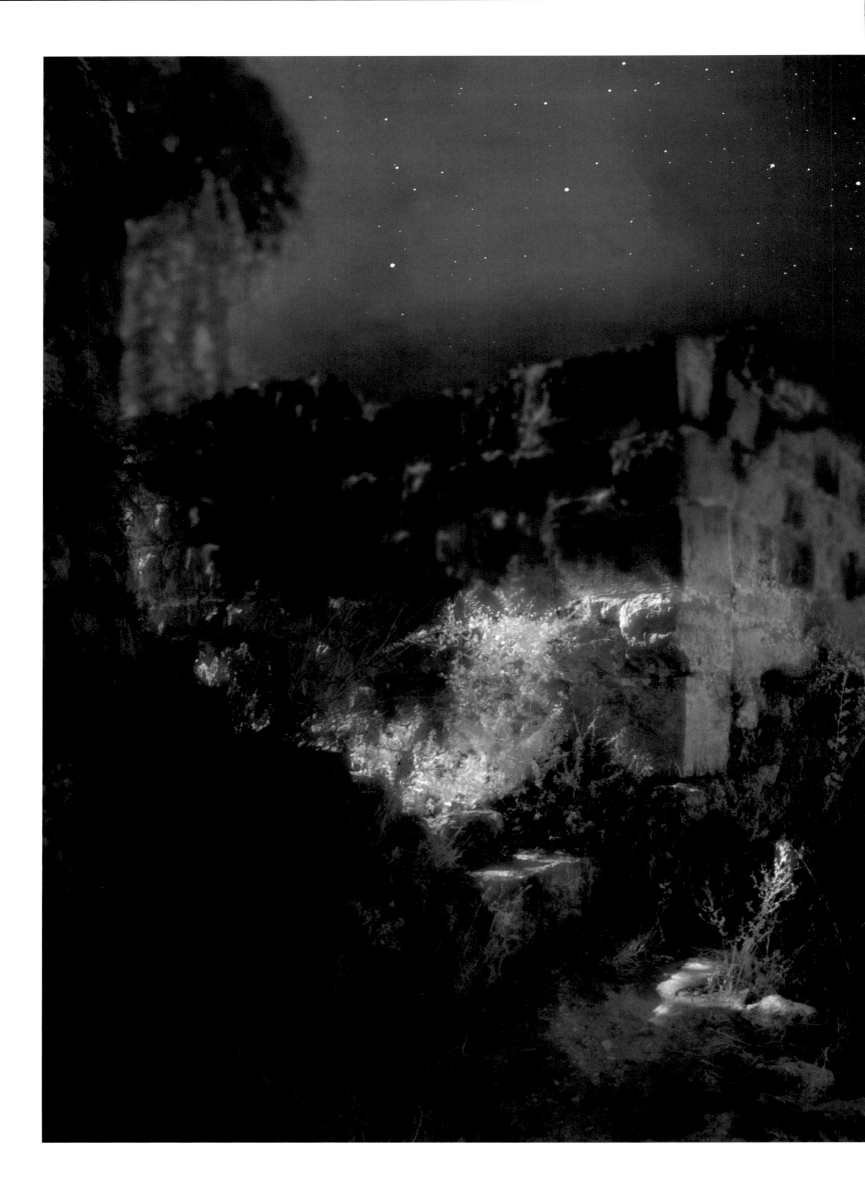

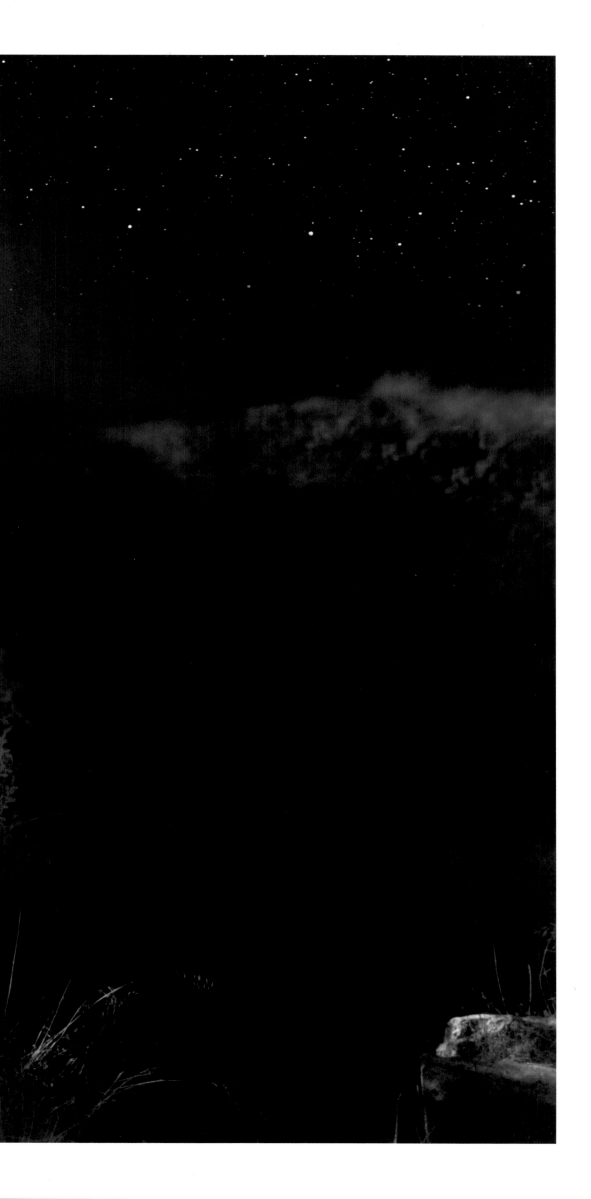

STEPS, 1998

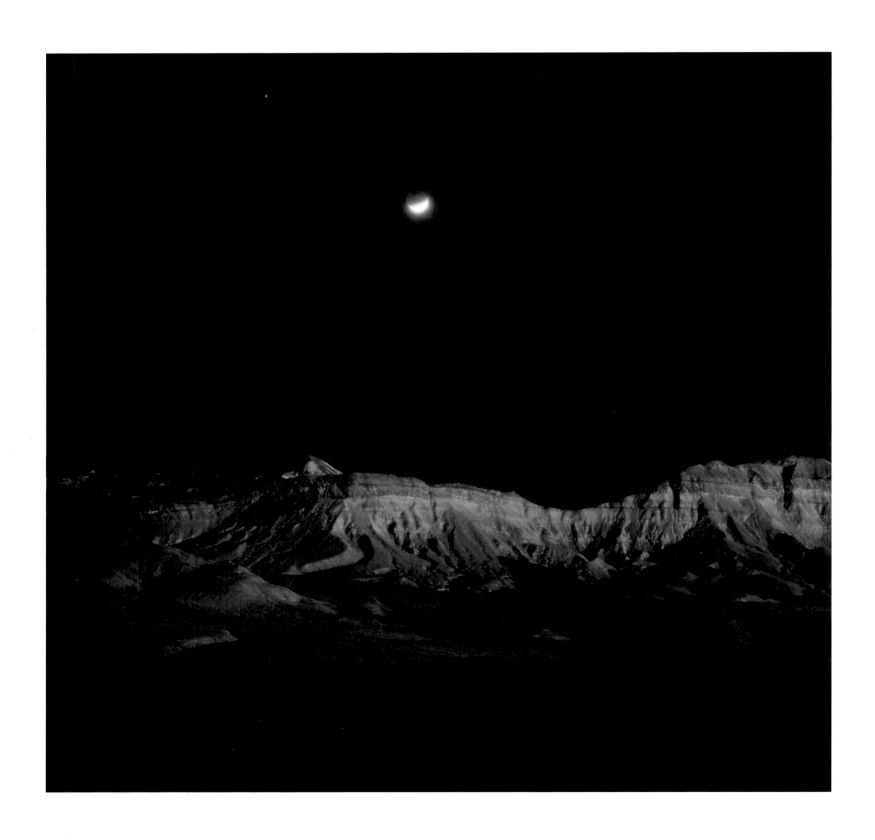

50 *SHEN RAMON*, 1998

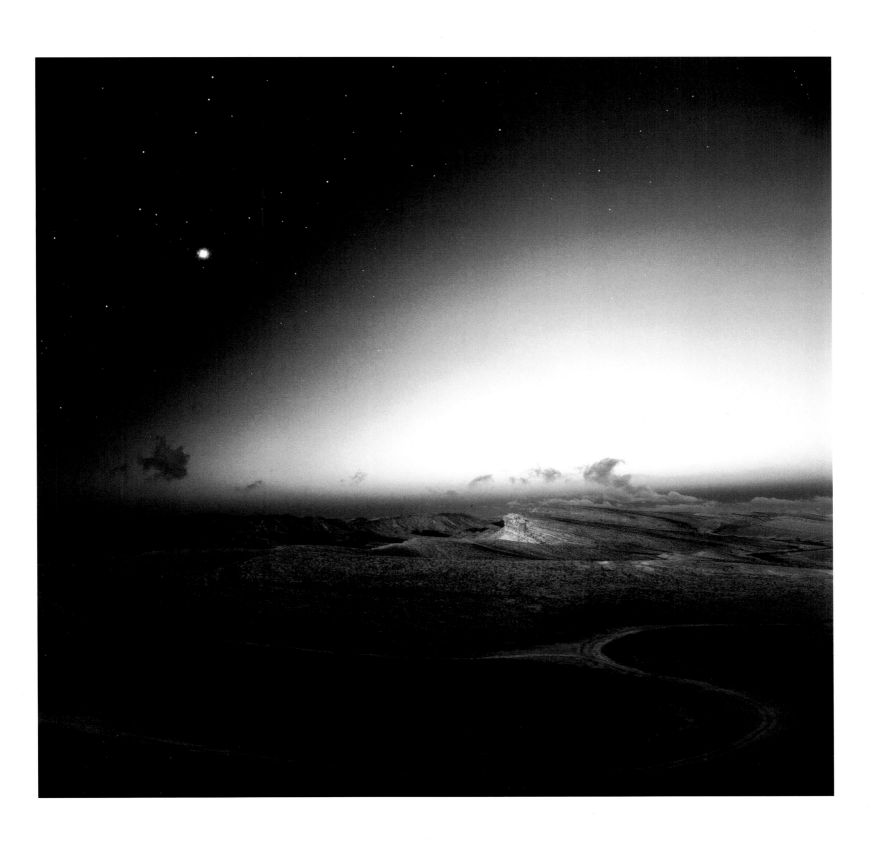

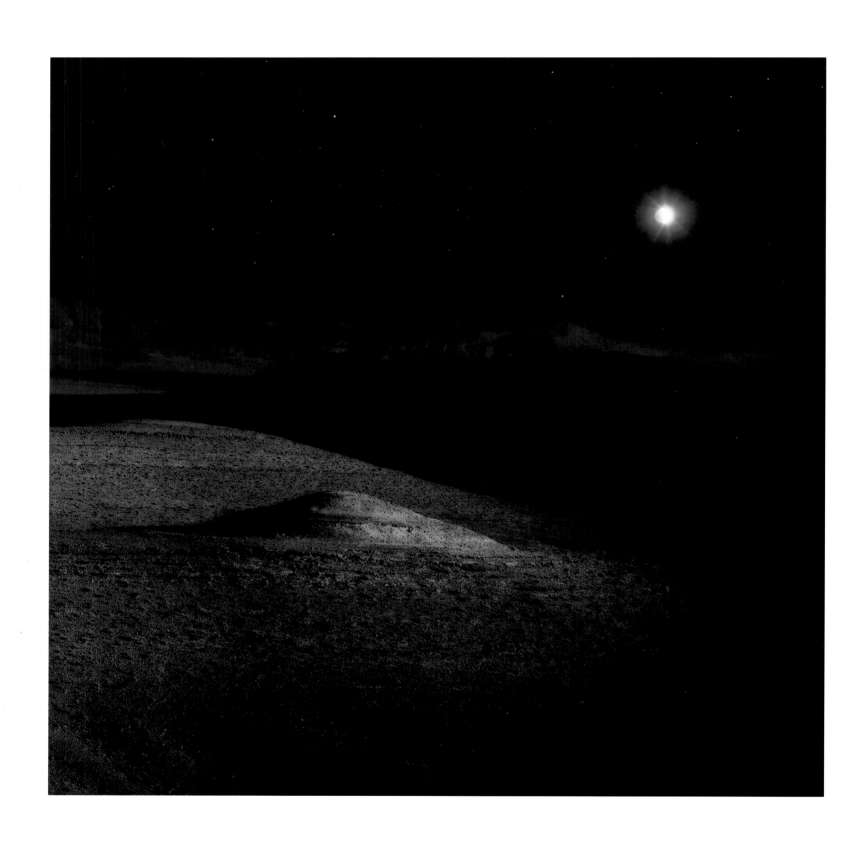

52 *PALUS SOMNI*, 1999

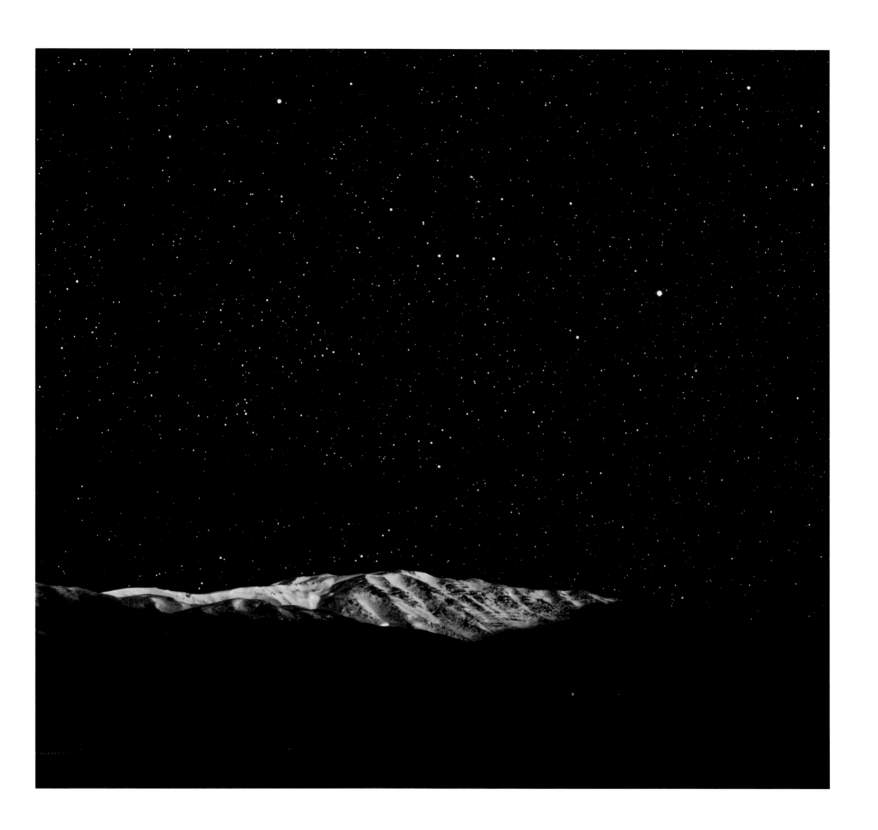

HAR HERMON, 1997 53

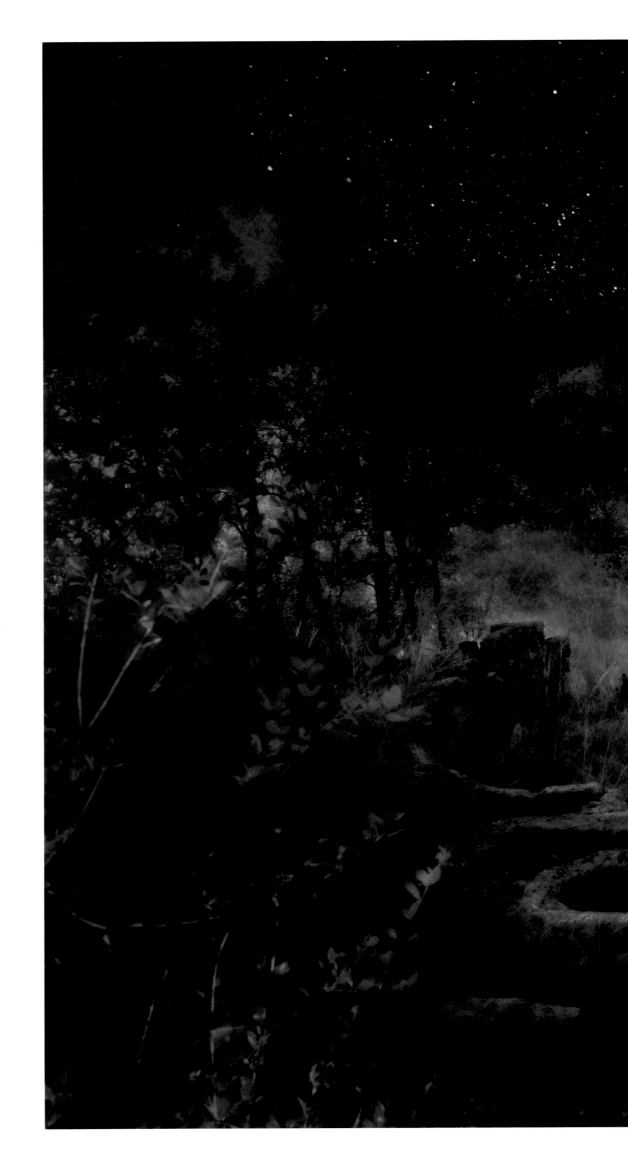

ANCIENT OLIVE PRESS, 1997

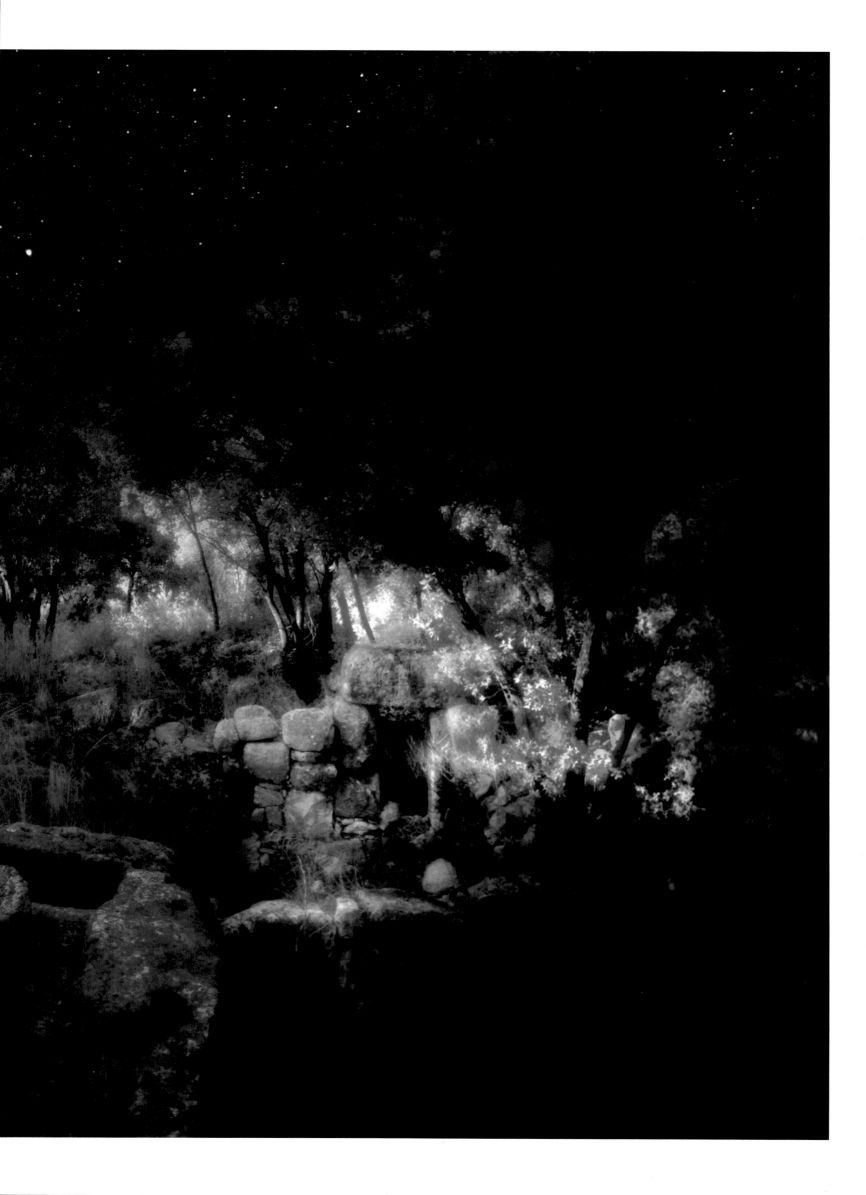

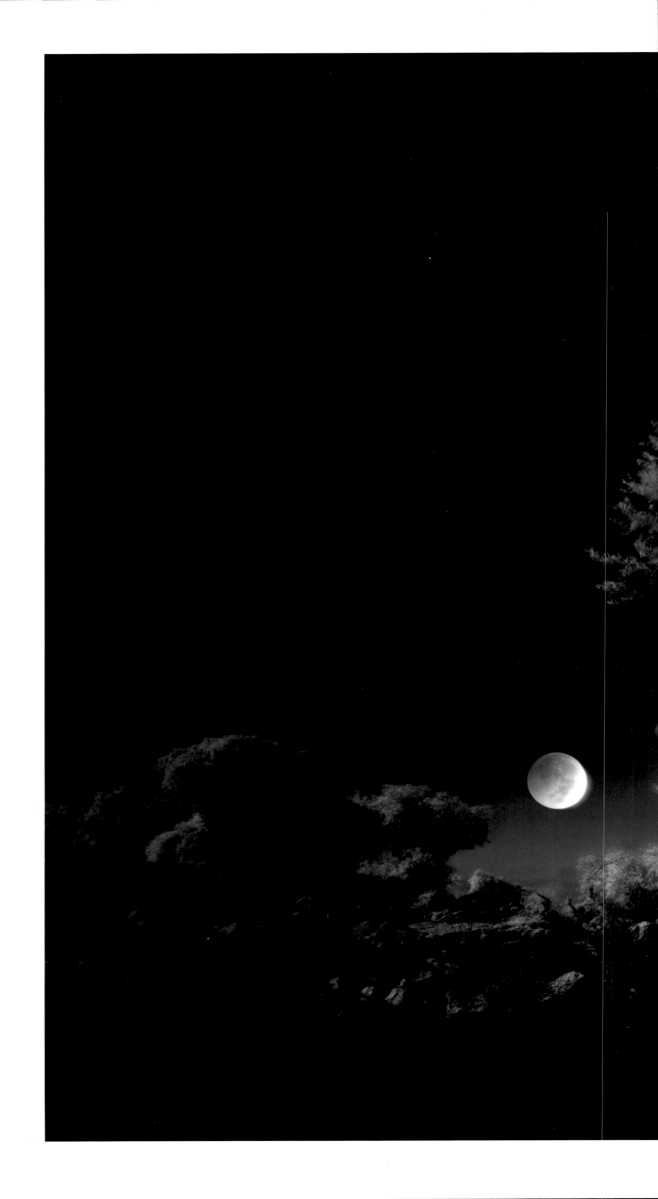

OLIVE TREE, 1997

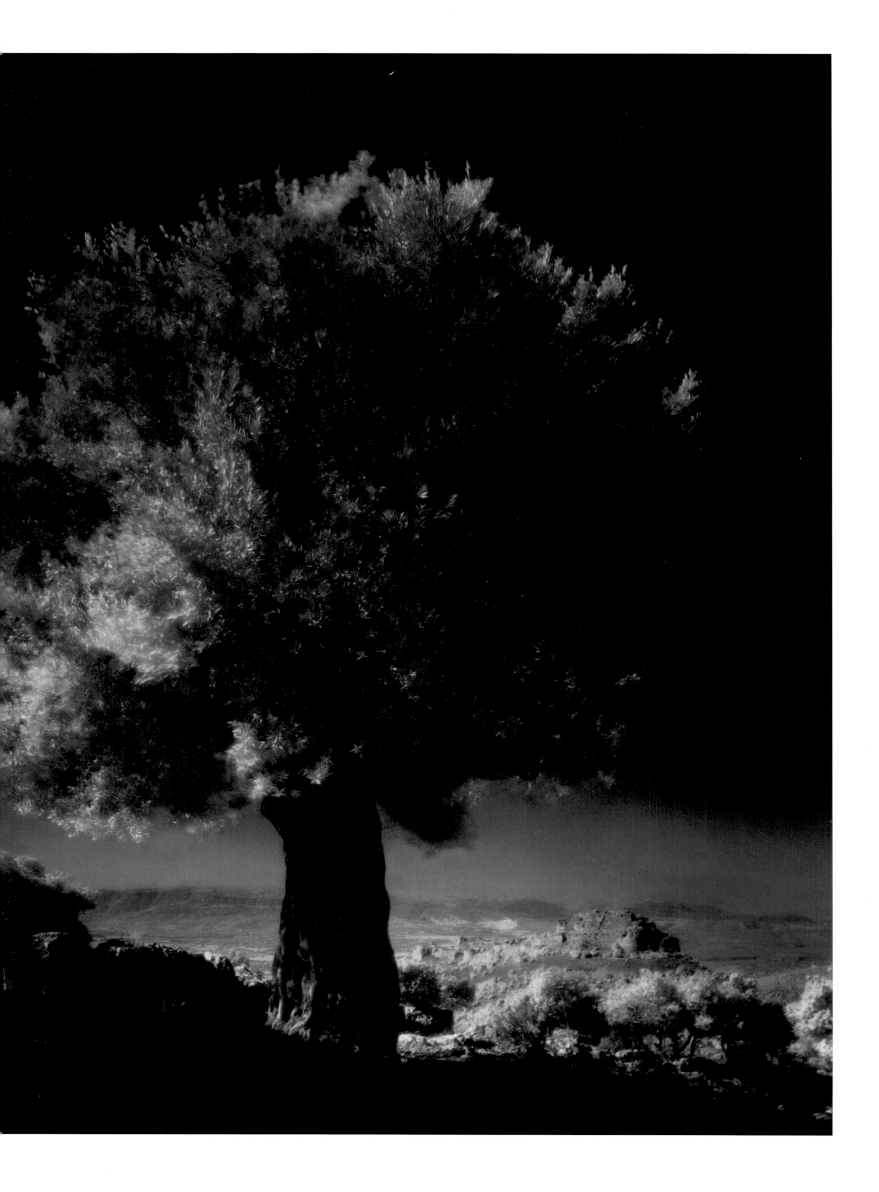

AFTERWORD

The horizon line separates the world we know from the unknown and the unknowable beyond. A dark night, however, may conceal the horizon, so that heaven is no longer so easily distinguished from earth. Only the glowing stars outline our small world. It is chilling to imagine the view of the heavens from the far side of the moon, without that familiar horizon.

I have spent entire nights gazing at the view through my small telescope, trying to understand the meaning of so many stars and galaxies, enchanted by the beauty and seeming order of what I see. I use what knowledge I have of these distant celestial bodies to inform my sight, but imagination is always the better part of the view. I look at a "place"—or is it a time?—twenty-five to thirty million light years away, at the spiral galaxy known as the Whirpool Galaxy, and I see the light of an object from so far in the past that I have no certainty that it is still there. I think I see the spiral arms of two galaxies tugging at one another—but it is such an effort to see it that it is hard to say how much of my view is sight and how much imagination. And the Whirlpool Galaxy is one of the brighter, larger objects available to my telescope. Perhaps this is the metaphor of these photographs: the horizon between knowledge and imagination, between the present and eternity, between substance

and spirit, certainty and doubt. No one can draw that line with precision, for we exist in all of these worlds at once.

Thus I am drawn to landscapes and ruins in my ancient and hallowed land, lit by the soft, antique light of stars that glow in the past and illuminate the present. These visions were inspired by the hundreds of nights I spent under the dome of the stars in the Sinai desert, sometimes walking by starlight along the dry riverbeds. The nights are dark and nearly monochromatic, but despite the murkiness, one can see well enough to walk among the mysterious, starlit landscapes.

Abraham was promised that his descendents would be as the dust of the earth and the stars above. Our spirit, like sand, is nearly indestructible, while our eyes are drawn to the stars. Like Abraham's, our feet are planted in the sand, but our vision and imagination can encompass the universe—and sometimes more. I am drawn towards the horizon and to the stars we meet at the human edge of the cosmos.

—NEIL FOLBERG
Jerusalem, 2001

ECLIPSED MOONRISE,
DEAD SEA, 1999

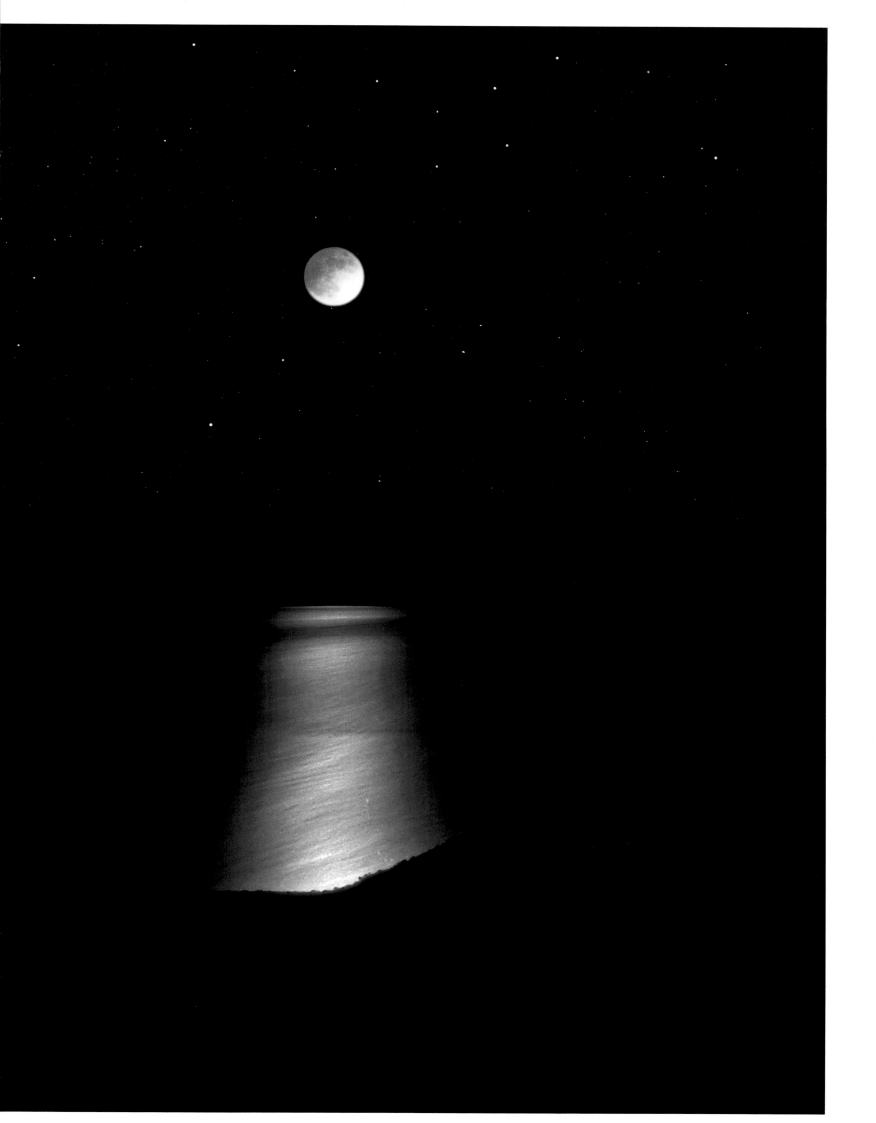

ACKNOWLEDGEMENTS

Many of the photographs of the starry sky were made on the balcony of the Wise Observatory in Mitzpeh Ramon, under dark skies in a sheltered area protected from strong winds. For access to this facility I am indebted to Tel Aviv University and all the staff and management, most particularly Ezra Mashal and Sammy Ben Gigi. Peter Ibbetson was especially helpful in overcoming some technical difficulties and has become a good friend, too.

The stars are a moving target, as any photographer who has photographed star trails knows. Making these photographs required a substantial investment in learning new skills that were required to photograph celestial objects. I would like, therefore, to thank amateur astronomer, telescope maker (and professional singer) Yossi Huri in Tel Aviv who showed me the way and helped me adapt my equipment to this special purpose. Similarly, photographer Dan Burkholder has generously shared all his knowledge and skills in making fine prints from digital images. I heartily recommend a visit to his website at www.danburkholder.com for any who are interested in the subject. Guide David Perlmutter has shown me some of the more obscure archaeological sites included in this book—it has been a rocky road that we have traveled together.

There are some people who have had an enormous impact on my work over the years, each in a very special manner. Rod Holt of San Francisco has encouraged and supported my work over a long period of time and has been a close friend of the family. He is a kind and generous man who believes in the power of images and art to effect change and to express basic human aspirations. Lin Arison is an extraordinary woman whose enthusiasm for life and creative work was an encouragement to me to continue my work. Her interest in the Mediterranean landscape enabled me to get out and make photographs that might otherwise never have been made. Her affection for the olive tree has also infected me, as is evident in these photographs. Both Rod and Lin have been of great assistance.

Finally, there is Aperture itself, led by Michael Hoffman. Michael has in his quiet, insistent manner encouraged innovative photography of the highest caliber for many, many years through the books and quarterly published by Aperture Foundation. Once he takes on a project he is relentless—he pushes everyone to their limits, with a total commitment to quality that is unparalleled. He has an instinct for truth and though he can be very demanding, he is also concerned (as few others are) for the integrity and welfare of the artist. This concern has now evidenced itself in two very different bodies of my own work published by Aperture, *And I Shall Dwell Among Them* and *Celestial Nights*. I like the challenge of changing my visual vocabulary from time to time, but I suspect that few publishers would have accompanied me on my journey. It has been a privilege for me to work with Aperture and with Michael on these projects.

My editor, Phyllis Thompson Reid, has been so efficient that I have hardly had a chance to get to know her—which leads me to hope that we will have the opportunity to work together once more. Stevan Baron, in charge of production, has made an all-out effort to make this book beautiful and faithful to the spirit of the original prints. Alan and Janet Klotz (Alan Klotz/Photocollect Gallery) in New York and Heather Snider and Scott Nichols (Scott Nichols Gallery) in San Francisco have promoted this work in their respective galleries for some years, for which I am very grateful.

My father, Joseph Folberg, would have been very pleased by this work and I can still hear in my mind his not-so-delicate critiques of individual prints, which I have been obliged to take into account when making new images and prints. My wife, Anna, is always the best audience and wisest critic; I find it very difficult to work when she is not at hand to give her opinions.

This book is dedicated to my mother, Doris Jean Folberg, who never gives up and always makes me laugh and smile.

—NEIL FOLBERG

CELESTIAL NIGHTS IS SUPPORTED BY

DAVID C. AND SARAJEAN RUTTENBERG ARTS FOUNDATION
AND BY F. ROD HOLT

APERTURE WISHES TO COMMEMORATE
THE WISDOM AND GENEROSITY OF JOSEPH FOLBERG
WHOSE SPIRIT AND DEVOTION CONTINUE IN THIS PUBLICATION

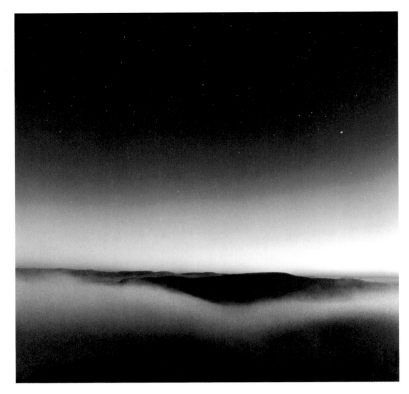

DAWN MIST, 2000

Copyright © 2001 by Aperture Foundation, Inc.; Photographs and Afterword copyright © 2001 by Neil Folberg; Introduction copyright © 2001 by Timothy Ferris.

All rights reserved under International and Pan-American Copyright Conventions. No part of this book may be reproduced in any form whatsoever without written permission from the publisher.

Library of Congress Catalog Card Number: 2001088024
Hardcover ISBN: 0-89381-945-X

Design by Michelle Dunn Marsh

Printed and bound by Sing Cheong Printing Co. Ltd., Hong Kong

The Staff at Aperture for *Celestial Nights*:
Michael E. Hoffman, Executive Director
Phyllis Thompson Reid, Editor
Stevan A. Baron, V.P., Production
Lisa A. Farmer, Production Director
Eileen Connor, Editorial Assistant

Aperture Foundation publishes a periodical, books, and portfolios of fine photography and presents world-class exhibitions to communicate with serious photographers and creative people everywhere. A complete catalog is available upon request.

Aperture Customer Service: 20 East 23rd Street, New York, New York 10010. Phone: (212) 598-4205. Fax: (212) 598-4015. Toll-free: (800) 929-2323. E-mail: customerservice@aperture.org

Aperture Foundation, including Book Center and Burden Gallery: 20 East 23rd Street, New York, New York 10010. Phone: (212) 505-5555, ext. 300. Fax: (212) 979-7759. E-mail: info@aperture.org

Visit Aperture's website: www.aperture.org.
Visit Neil Folberg's website: www.neilfolberg.com

Aperture Foundation books are distributed internationally through:

CANADA: General/Irwin Publishing Co., Ltd., 325 Humber College Blvd., Etobicoke, Ontario, M9W 7C3. Fax: (416) 213-1917.

UNITED KINGDOM, SCANDINAVIA, AND CONTINENTAL EUROPE: Aperture c/o Robert Hale, Ltd., Clerkenwell House, 45-47 Clerkenwell Green, London, United Kingdom, ECIR OHT. Fax: (44) 171-490-4958.

NETHERLANDS, BELIGUM, LUXEMBOURG: Nilsson & Lamm, BV, Pampuslaan 212-214, P.O. Box 195, 1382 JS Weesp, Netherlands. Fax: (31) 29-441-5054.

AUSTRALIA: Tower Books Pty. Ltd., Unit 9/19 Rodborough Road, Frenchs Forest, Sydney, New South Wales, Australia. Fax: (61) 2-9975-5599.

NEW ZEALAND: Southern Publishers Group, 22 Burleigh Street, Grafton, Auckland, New Zealand. Fax: (64) 9-309-6170.

INDIA: TBI Publishers, 46 Housing Project, South Extension Part-I, New Delhi 110049, India. Fax: (91) 11-461-0576.

For international magazine subscription orders to the periodical *Aperture*, contact Aperture International Subscription Service, P.O. Box 14, Harold Hill, Romford, RM3 8EQ, United Kingdom. One year: $50.00. Price subject to change. Fax: (44) 1-708-372-046.

To subscribe to the periodical *Aperture* in the U.S.A. write Aperture, P.O. Box 3000, Denville, New Jersey 07834. Toll-free: (800) 783-4903. One year: $40.00. Two years: $66.00.

First Edition

10 9 8 7 6 5 4 3 2 1